BY STEAMER TO THE ARGYLLSHIRE COAST

ALISTAIR DEAYTON

AMBERLEY

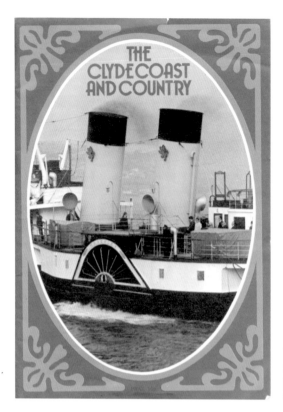

The cover of a tourist brochure from
1973, showing *Waverley*'s funnels and
paddle box in her 1973 CalMac colour
scheme.

First published 2013

Amberley Publishing
The Hill, Stroud
Gloucestershire, GL5 4EP

www.amberley-books.com

British Library Cataloguing in Publication Data.
A catalogue record for this book is available from the British Library.

ISBN 978 1 4456 1285 0
E-book ISBN 978 1 4456 1306 2

Typeset in 10pt on 13pt Sabon.
Typesetting and Origination by Amberley Publishing.
Printed in the UK.

Introduction

The Argyllshire Coast of the Firth of Clyde has seen a wide variety of steamer services over the two hundred and one years since *Comet* first sailed from Glasgow to Helensburgh. (The parts historically in Dunbartonshire from Helensburgh up the Gareloch and on the eastern side of Loch Long, which are now administered by Argyll & Bute Council, have been included in this volume.)

At the beginning of the steamboat era there were few towns or villages in this area with the exceptions of Helensburgh, founded in 1776 as a planned town; Kilmun, which had a church where the Dukes of Argyll, the chiefs of the Clan Campbell, were buried; Inveraray, with its Castle, the seat of the Clan Campbell, and where another planned town had been built in the late eighteenth century; Lochgilphead, yet another planned town dating from around 1770, where low water meant that Ardrishaig, at the entrance to the Crinan Canal, became its port; Tarbert, with its old castle; and Campbeltown, which is of ancient origin and situated near the foot of the Kintyre peninsula which was, in effect, an island before improvements to the road network in the 1930s.

Most of the settlements on the Argyllshire shore were created by the steamers in the mid-nineteenth century, when Glasgow merchants built houses there, moving their wives and families down to the coast for the summer months, and commuting weekly from the city. Hamlets like Dunoon became towns and villages such as Blairmore, Sandbank and Innellan developed.

As the nineteenth century progressed, the Clyde steamers began to be used for pleasure as well as for vital transport links. The routes to the Argyllshire piers were often very scenic, the supreme example being the sail through the Kyles of Bute, and so the pleasure cruise developed.

The huge population growth in Glasgow during the industrial revolution provided a ready market for the steamer trips 'doon the watter' to the Clyde Coast. The advent of railway services to the new piers at Craigendoran (1882), Gourock (1889), Wemyss Bay (1865) and Greenock (Princes Pier) (1894) in the latter years of the nineteenth century stimulated such trade. By that time, a trip down the River Clyde had become an unpleasant experience, with the smell of untreated sewage discharged into the river pervading the whole trip. It was not until the building of a sewer system for Glasgow in the late nineteenth century that it was alleviated, helped by the advent of sewage discharge facilities at Shieldhall and Dalmuir in the early twentieth century, from where the sewage sludge was taken down by steamer to Garroch Head, at the south end of the island of Bute and discharged into the sea there.

Whole families would decamp to tenement flats in Dunoon doing the Glasgow Fair fortnight in the middle of July. The advent of half-day closing for shops in 1912 meant a wider market for day trips on the Firth of Clyde for those who worked in shops.

A holiday or a day trip to the Coast was extremely popular in the 1930s and into the 1950s, but extensive ownership of motor cars from the post-war years onwards, giving

a much wider variety of alternative destinations, led to a decline in steamer patronage. Cheap foreign holidays, in such places as the Spanish Costas and Majorca, replaced the fortnight at the Coast for many Glaswegians. The replacement of an aging steamer fleet with car ferries also contributed to the decline of steamer services while harsh economics and rampant inflation led to hefty increases in fares for day trips, which had been kept artificially low for decades, with day excursions being below £1 up to the sixties. The new owners, Caledonian MacBrayne, had no place for pleasure trips in their programme, which was to provide essential transport services only and no fripperies.

The towns and villages of the Argyllshire Coast did not boast the glitz and man-made attractions of the English seaside resorts with their fancy piers with pavilions, amusement arcades and entertainments on the pier, but were of a more relaxed and simpler nature, giving the inhabitants of the Glasgow area a cheap and convenient taste of the Highlands, both in the scenery and the simple lifestyle.

The preserved paddle steamer *Waverley* is the last surviving sea-going paddle steamer in the world and became the final Clyde steamer in service after the retirement of the turbine steamer *Queen Mary* in 1977. Piers on the Argyllshire Coast have been well served by her, with regular calls at Kilcreggan, Dunoon, Blairmore, which was reopened in 2005, Tighnabruaich and Tarbert. The *Waverley* still serves these places today.

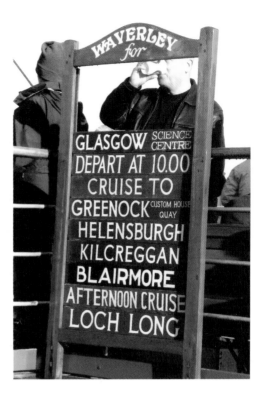

The fan boards on *Waverley* as she awaits departure from her Science Centre berth on 17 October 2009, all, bar the first, for calls on the Argyllshire Coast.

Advertisements for steamer trips to various locations on the Argyllshire Coast in the *Evening Times* at the end of August 1912, including special sailings to the *Comet* Centenary Review.

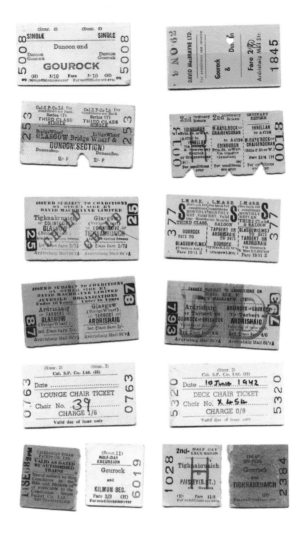

A selection of tickets for steamer trips to the Argyllshire Coast. From top left, clockwise: CSP single from Gourock to Dunoon, used 1970; David MacBrayne single from Gourock to Dunoon, used 9 November 1962; CSP three-part ticket from Edinburgh to Innellan, unused; LMSR Third Class three-part ticket from Glasgow to Tarbert ot Ardrishaig, unused; David MacBrayne Third Class day return from Greenock or Gourock to Tarbert or Ardrishaig; CSP Deck Chair Ticket, used on 10 June 1972 on *Queen Mary II* or *Waverley*; CSP Cheap Off Peak – severed half – from Gourock to Tighnabruaich used 21 June 1958; CSP Second Class Half Day Excursion – severed half – Tighnabruaich to Paisley Gilmour St via Gourock, used 20 May 1965; CSP Half-Day Excursion Gourock to Kilmun Sec, used 8 July 1964 – severed half; the reverse of a CSP Off Peak return – severed half – from Gourock to Craigendoran, used on 14 September 1968, and stating, 'Valid as advertised on authorised trains'!; CSP Lounge Chair ticket from *Queen Mary II*, used 30 June 1969; David MacBrayne Third Class Juvenile Organisation under 10 years – return from Glasgow (Bridge Wharf) to Tarbert or Ardrishaig, unused; David MacBrayne First Class child return from Glasgow (Bridge Wharf) to Colintraive or Ardrishaig; CSP Third Class single from Glasgow (Bridge Wharf) to Dunoon Sect.

'Doon the Watter'

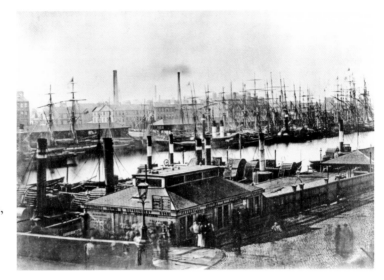

The famous Kibble photograph of the Broomielaw in 1852, showing a large number of steamers ready to depart for the Clyde Coast.

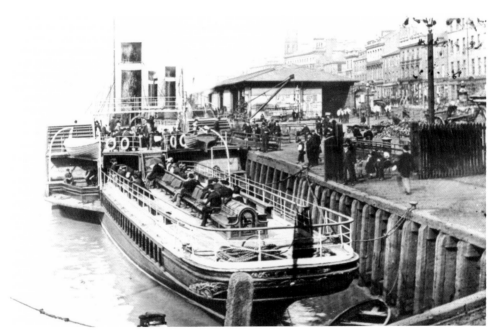

Buchanan's *Eagle* of 1864 at the Broomielaw in 1876, prior to construction starting on the Central Station Railway Bridge. Note the parapet of Jamaica Bridge at the bottom left hand corner. Note the clever stepped design of the wharf allowing the maximum number of steamers to berth and sail with ease. At least in its later years, this quay was known as Bridge Wharf (North Side), with the street behind the buildings being named the Broomielaw.

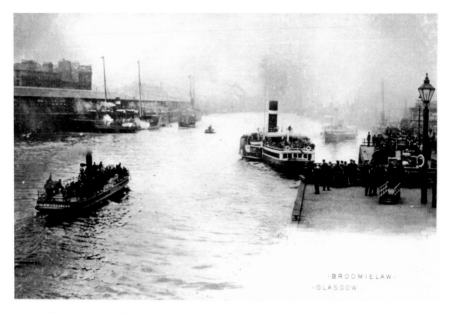

As the line from the 'Song of the Clyde', made famous by Kenneth McKellar, goes, 'There's paw and maw at the Broomielaw, going Doon the Watter for the Fair'. A crowded *Isle of Arran* leaves for the coast as *Madge Wildfire* arrives on the morning run from Kilmun, seen in an undivided back postcard view from the earliest years of the twentieth century.

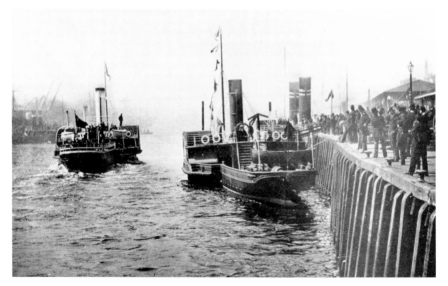

Steamers at the Broomielaw in 1898, with *Athole* moored at the quay in her final season, *Benmore* having just left for Rothesay sporting Captain Williamson's new funnel colours, and the second *Lord of the Isles*, moored further downstream from the photographer. Note the fan boards, giving the piers called at, on *Athole*, a term that has persisted to this day on *Waverley*, although it is many years since horizontal boards replaced the fan-shaped displays.

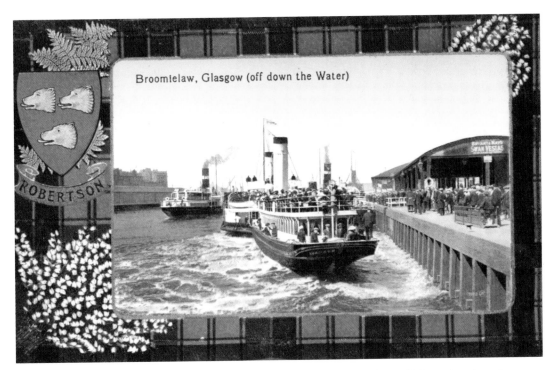

Broomielaw, Glasgow (off down the Water)

Ivanhoe departing from the Broomielaw, with *Isle of Arran* heading off downriver in a shot taken between 1912 and 1913.

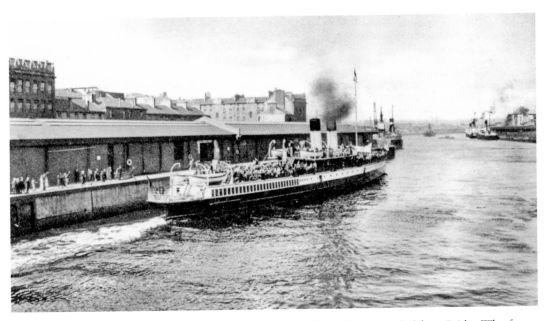

From 1929 until 1969, steamers sailing down the river from Glasgow sailed from Bridge Wharf on the south side of the river, following the completion of the King George V Bridge. *King Edward* is seen there in pre-war condition.

Caledonia at Bridge Wharf in the late 1960s, with *Queen Mary II* moored on the other side of the river, waiting to move over to the berth once *Caledonia* has left. *Caledonia* made the last ever sailing from the wharf on 15 September 1969.

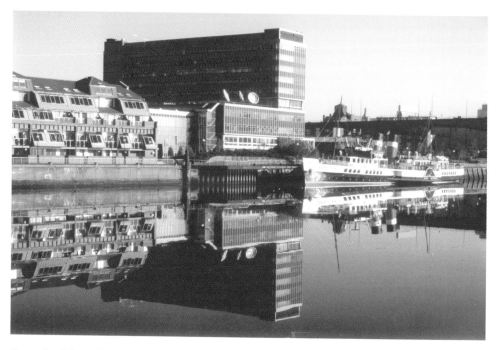

From the debut of her second career in 1975 until 2005, with the exception of the years 1978 to 1983, Anderston Quay was used by *Waverley* as the base for her Glasgow sailings. The adjacent end building on the quayside is the headquarters of Waverley Steam Navigation Co. some forty years after the company was formed.

Come Aboard

m.v.

GLEN SANNOX

THE Clyde Cruise Ship
from

Glasgow Stobcross Quay

LEAVE AT	TO	ARRIVE BACK	RETURN FARE £	£	FAMILY TICKET £	£
SUNDAYS	**18 JUNE until 27 AUGUST**					
1100	GOUROCK	2020	1.65			
	DUNOON	2020	2.95		6.65	
	ROTHESAY	2020	3.95		8.85	
	KYLES of BUTE and LOCH RIDDON	2020	5.95	5.05	13.35	11.35
SUNDAYS	**18 JUNE until 27 AUGUST**					
1650*	GOUROCK and UP-RIVER CIRCLE	2020	1.65			
	* Train from Central Station					
MONDAYS	**19 JUNE until 28 AUGUST**					
1100	GOUROCK	2029*	1.85			
	DUNOON	2029*	2.95		6.65	
	ROTHESAY	2029*	3.95		8.85	
	KYLES of BUTE (TIGHNABRUAICH)	2029*	5.95	5.05	13.35	11.35
	* At Central Station, by train from Gourock					

A connecting bus departs Cathedral Street (outside Buchanan Bus Station) at 10.35 for Stobcross Quay and runs via North Hanover Street, Union Street and Argyle Street; also operates in the reverse direction to connect with Glen Sannox's arrival at Stobcross Quay. (Bus service No. 99 Fare 10p.)

Daily Cruises by Glen Sannox from GOUROCK PIER - ask for a free brochure at your local station, Information Centre George Square, Travel Centre, Buchanan Bus Station, Anderston Cross Bus Station, Ticket Centre Candleriggs.

Family Tickets

Valid for Two Adults and one or two children travelling together and returning the same day.

Book in advance and save money - Fares in red are those which apply in respect of tickets purchased at the offices detailed below not later than the day prior to day of sailing.

Right: An advertising card, advertising cruises from Glasgow (Stobcross Quay) by the car ferry *Glen Sannox* to Rothesay and the Kyles of Bute in 1978, after she had replaced Queen Mary on the sailings from Glasgow.

Below: The masts and funnels of ocean-going ships in Princes Dock could be glimpsed behind the sheds along the river.

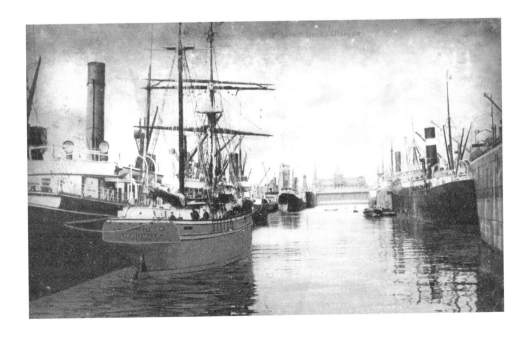

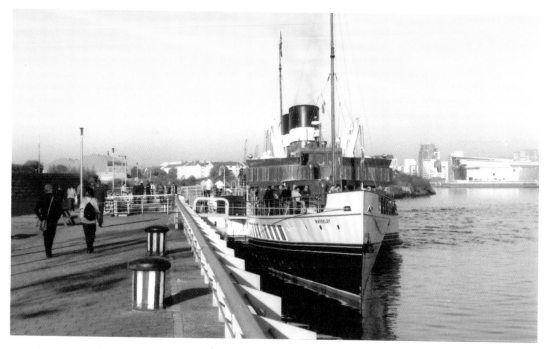

Since 2006, *Waverley* has sailed from a berth at the Science Centre, built on infilled ground that was once Princes Dock.

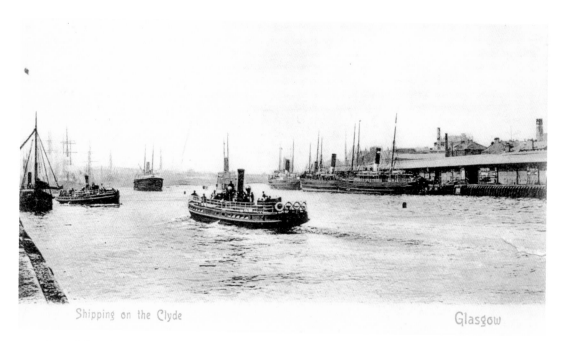

One of the *Cluthas*, small steamers which operated a service along the river from 1894 to 1903, in mid-river with another leaving a call on the south side of the river, and three Laird Line steamers moored at the north bank quays.

In 1978 and 1979, the motor vessel *Queen of Scots* ran trips from Princes Dock to the Clyde Coast for BB Shipping (Dunoon) Ltd. She is seen here returning to her berth after an excruciatingly slow trip. On the left is the west corner of *Waverley's* current berth.

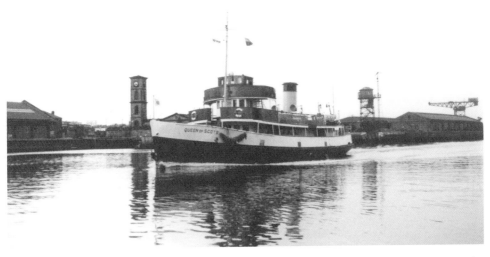

Queen of Scots passing the entrance to Queens Dock. She had been built in 1935 as *Coronia* for service at Scarborough, and had served at Bournemouth as *Bournemouth Queen* from 1968 until 1973, when she was sold to Sir Robert McAlpine to run a commuter service from Rothesay to his oil rig construction yard at Ardyne, which she did until 1977, when she spent a spell under charter to *Waverley* Steam Navigation Co., replacing *Waverley* while she was being repaired following her contretemps with the Gantocks. In 1982 she was sold for static use on the River Medway in Kent.

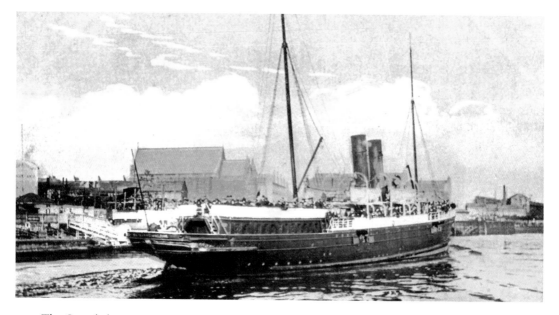

The Campbeltown steamer *Davaar* passing the yard of her builders, the London & Glasgow Engineering & Iron Shipbuilding Co. in a shot taken prior to 1903, when her two funnels were reduced to one.

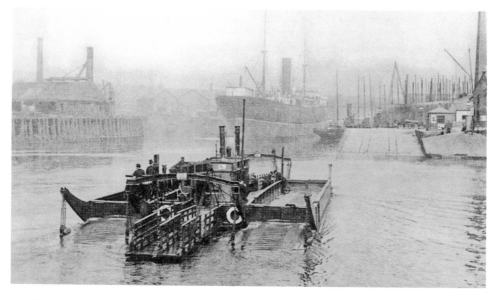

On the way down river, the steamers would pass the Govan vehicular ferry, seen here c.1900, with *Kinloch* of the Campbeltown Company moored alongside the slipway. As the song goes on, 'There's Bob and Mary at the Govan Ferry, wishing jet propulsion could be there'. This was Govan Ferry No. 2, built in 1875 and in service there until 1903, later being used at Erskine for a short while and scrapped around 1912. In the background is A & J Inglis' Pointhouse shipyard and to the left is th repair and building yard of D & W Henderson, originally Tod and McGregor.

Right: From 1890 until 1966 three strange vehicular ferries could be seen crossing the Clyde in Finnieston, Govan and Whiteinch, the latter closing on the opening of the Clyde tunnel in 1963.

Below: On the way downriver, the steamers would pass the Clyde shipyards, often with long gantries at the building berths, as in this image of *Carrick Castle* from the 1870s. To quote again from 'The Song of the Clyde', 'From Glasgow to Greenock in towns on each side/The hammer's ding-dong is the Song of the Clyde.'

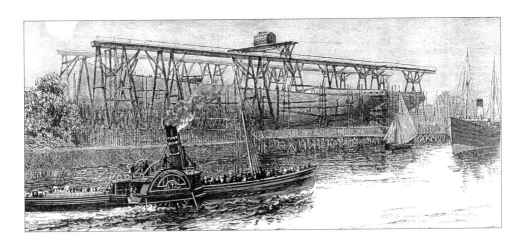

Partick Pier was a call by the Doon the Watter steamers until it was closed in 1906. Buchanan's *Isle of Bute* is seen moored there.

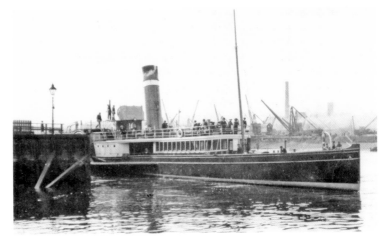

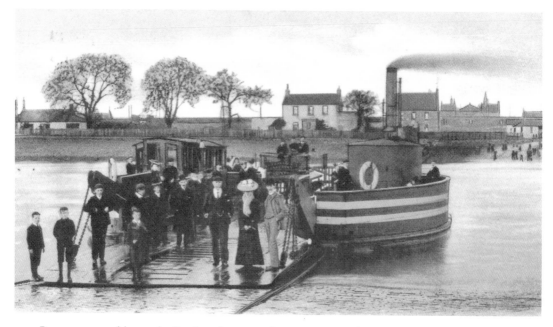

Passengers would pass the Renfrew ferry, seen here in a postcard posted in 1905. This ferry was built in 1897 and served until 1912, then being a reserve vessel until 1936, when she was sold for use at Kessock, but was discovered to be too wide for the locks on the Caledonian Canal and was then broken up.

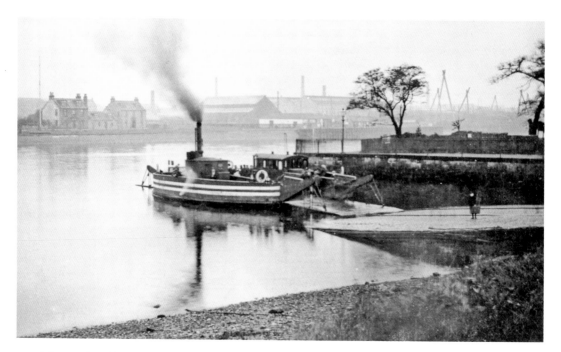

The Renfrew ferry at its northern slipway at Yoker.

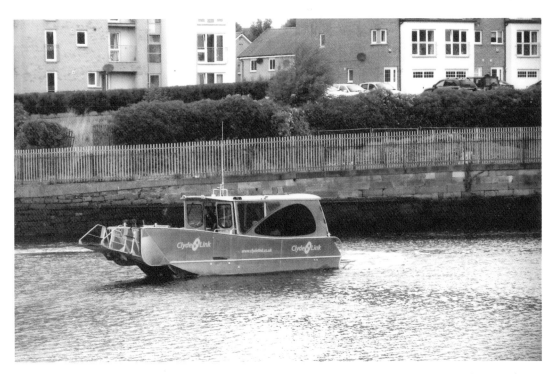

There is still a passenger ferry from Renfrew to Yoker, now operated by Clydelink, with a vessel that seems to resemble a floating bathtub. Such is progress.

A chain ferry operated at Erskine from 1911 until replaced by the Erskine Bridge in 1971.

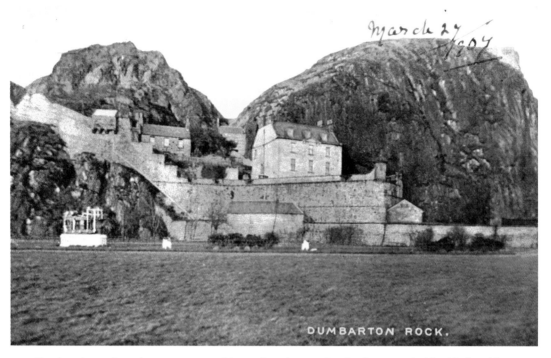

march 27 /9 04

DUMBARTON ROCK.

Further down river, the steamers would pass Dumbarton Castle, the stronghold with the oldest recorded history in the UK, dating back to the fifth century, with the preserved side-lever engine of the steamer *Leven*, dating back to 1823, on display to the left of this postcard view, posted in 1907. This engine is now in the grounds of the Denny Ship Model tank at Dumbarton.

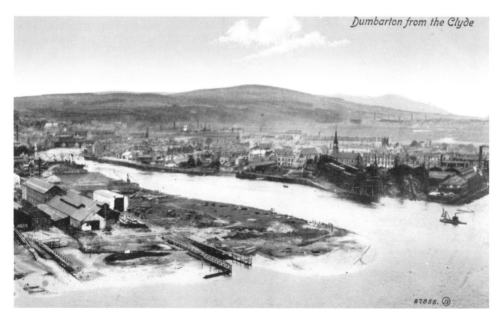

Dumbarton from the Clyde

67856.

Beyond the Rock, a quick chance to look up the River Leven, to the town of Dumbarton and William Denny's famous shipbuilding yard.

Helensburgh and the Gareloch

Above: Helensburgh was the destination of the first Clyde steamer, *Comet*, in 1812. Her owner Henry Bell owned the Baths Hotel there and was the town's first provost from 1807 to 1809. This late nineteenth century engraving shows two unidentified paddle steamers off the pier.

Right: An 1866 advertisement for the North British Steam Packet's *Meg Merrilies*' service from Ardrishaig to Glasgow, with a connecting coach from Oban. This service only lasted four weeks.

OBAN, GLASGOW, AND EDINBU
Via ARDRISHAIG AND HELENSBURC

MAY ARRANGEMENTS.

A COACH will leave OBAN every lawful day at 8-15 A.M., arriving in ARDRISHAIG at 2-15 P.M.; thence per new Saloon Steamer,

"MEG MIRRILEES,"

to Helensburgh, and per Train arriving in Glasgow at 8-5 P.M. and Edinburgh at 10 P.M.

A Train will leave Edinburgh at 6-35 A.M., Glasgow (Queen Street Station) at 7-50, for Helensburgh; thence per Steamer at 8-55 for Ardrishaig, and Coach to Oban, arriving at 7 P.M.

BUCHANAN & DICK.

OBAN, 27th April, 1866.

ROUTE.

Via Soroba, Loch-Nell, Kilmore, Glenfeochan House, Loch-Feochan, Dunach, Kilninver, Carnchellain, Euchar Water, Glen Gaillen, Oude Water,

THE PASS OF MELFORT,

The Melfort Powder Works, Loch-na-Dhremnin, Kilmelfort, Loch Melfort, Island of Shuna, Barbreck House (near which is Prince Olave's grave), Loch Craignish, Craignish Castle, Kintra, Carnassrie Castle (once the residence of Bishop Carswell, and one of the cradles of the Earl of Argyle's Insurrection against James VII.) (here Passengers for Loch-Awe branch off to Ford), Skeodnish Water, Kilmartin House, Kilmartin, The Druidical Pillars, Caltonmore Castle (residence of Malcolm Grofs of Poltallach), Kiran, Kilmichael Manse (where Thomas Campbell the Poet wrote his well known beautiful lines "On Visiting a Scene in Argyleshire"), Kilmichael Glassary, Add Water, Cairnban, Crinan Canal, Achinda-roch, Gilp Water, The Parsonage (residence of the Bishop of Argyle), Lochgilphead, Kilmory Castle, Ardrishaig.

Fares—Oban to Ardrishaig................10s. and 12s.

„ to Helensburgh,....................Cabin, 12s.

„ to Glasgow,...... Cabin and First Class, 12s. 6d.

„ to Edinburgh,...... do. do. 18s. 6d.

Driver's Fee, 1s.

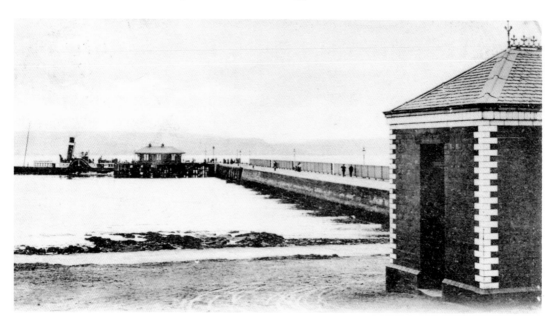

The NB's *Lucy Ashton* of 1888 departing Helensburgh Pier in a postcard view posted in 1909. The pier was closed to steamers in 1952 and was reopened for use by *Waverley* in 1979.

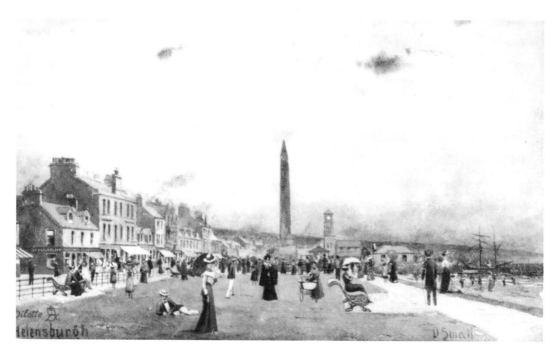

There was an opportunity at Helensburgh to walk along the seafront, as in this Tuck's 'Oilette' postcard from the early twentieth century from the 'Clyde Watering Places' series. The obelisk in the centre of the illustration is a monument to Henry Bell, erected in 1872.

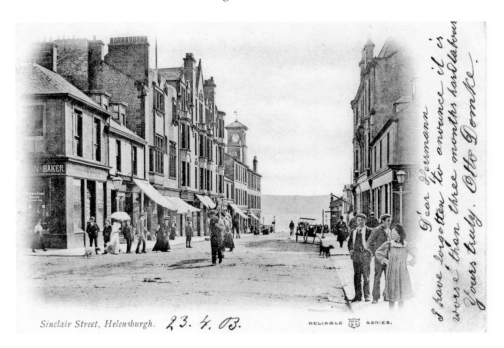

Sinclair Street, Helensburgh. 23. 4. 03.

Above: Visitors to Helensburgh could also visit the shops in Sinclair Street, seen here in a postcard view, posted in 1903.

Right: Helensburgh was a regular destination for evening cruises in the 1920s and 1930s, as in this handbill for a cruise from Innellan and Dunoon on 2 July 1935 by *Kylemore*. This cruise had originated in Rothesay and had also picked up passengers at Craigmore.

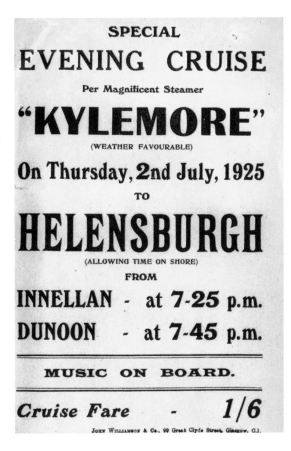

SPECIAL
EVENING CRUISE
Per Magnificent Steamer
"KYLEMORE"
(WEATHER FAVOURABLE)
On Thursday, 2nd July, 1925
TO
HELENSBURGH
(ALLOWING TIME ON SHORE)
FROM
INNELLAN - at 7·25 p.m.
DUNOON - at 7·45 p.m.

MUSIC ON BOARD.

Cruise Fare - 1/6

JOHN WILLIAMSON & Co., 99 Great Clyde Street, Glasgow. C.1.

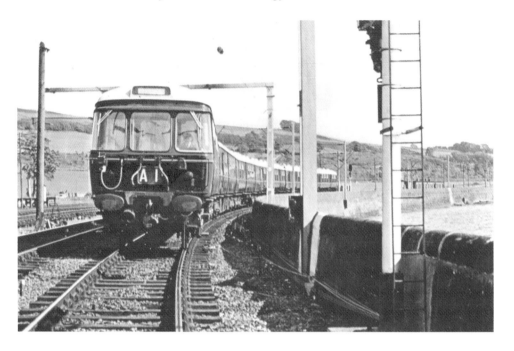

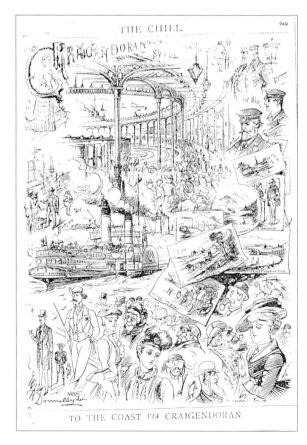

Above: A mile east of Helensburgh lay Craigendoran Pier, built by the North British Railway in 1882 and closed in 1972. From 1960 Craigendoran was served by the electric 'Blue Trains', one of which is seen here arriving at the station from Airdrie and Glasgow.

Left: A multi-faceted drawing of Craigendoran, showing the 1866 *Dandie Dinmont*, the curved pier platform, and a wide selection of passengers and station staff, from a magazine named *The Chiel*, originally published in July 1885.

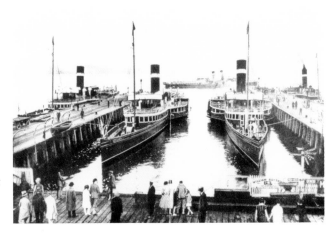

Craigendoran Pier had two finger piers, seen here in an early 1930s view, with, from left to right, *Marmion, Kenilworth, Talisman* and *Lucy Ashton*, with the 1931 *Jeanie Deans* lying off, in what may be a faked photograph with the 1931 steamer added before printing.

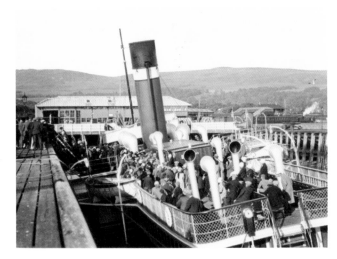

Marmion at Craigendoran, with passengers disembarking up a steep gangway at low tide, and a train in the pier platform, readying itself for departure to Glasgow Queen Street (Low Level) and stations further east.

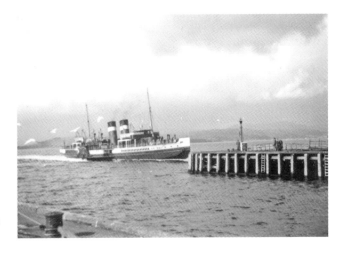

Jeanie Deans arriving at Craigendoran in 1946, still under London & North Eastern Railway ownership and resplendent after reconditioning following her war service. Craigendoran became a summer only call in 1966, the final call being made by *Maid of Cumbrae* in 1972.

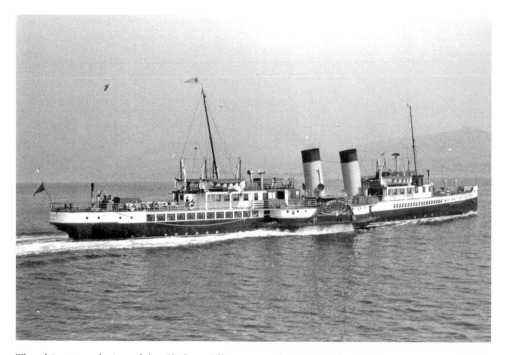

The ultimate evolution of the Clyde paddle steamer, the LNER's *Jeanie Deans*, seen towards the end of her career in 1964.

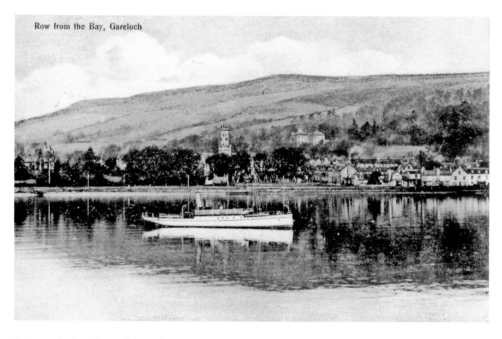

Prior to the building of the submarine base at Faslane, the Gareloch was a favourite destination for holidaymakers seeking a taste of the Highlands within easy reach of Glasgow. Row, now known as Rhu, is seen here, with a small steam yacht anchored in the loch.

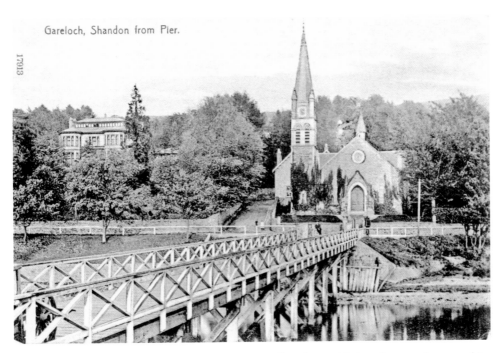

Gareloch, Shandon from Pier.

Beyond Rhu Narrows, the excursionist came to Shandon, with its pier seen here, and its hydropathic establishment, opened in 1880.

Faslane was the location of a naval base during the Second World War, and after the war a shipbreaking yard was established there. Here, in 1966, are the Union Castle liner *Braemar Castle* and some small naval craft being broken up.

The former Dover to Dunkirk train ferry *Hampton Ferry* of 1934, renamed *Tre Arddur*, is seen here in 1969 with a naval ship being broken up. In 1968 Faslane became the base for nuclear submarines and the whole area today has been taken over by the Royal Navy.

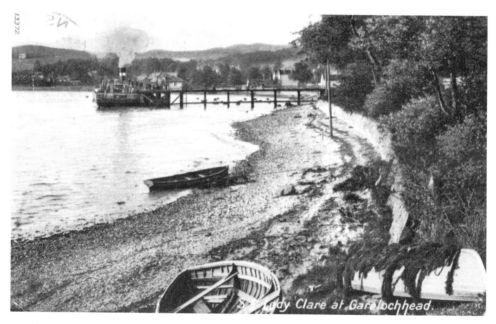

Garelochhead at the head of the loch was served by the North British Railway steamers like *Lady Clare*, seen here in a postcard view posted in 1906. A North British Railway guidebook states: 'The North British Railway's fast and commodious steamers sail between Craigendoran Pier and Lochgoilhead in connection with trains on West Highland Railway, calling at Helensburgh (the Brighton of Scotland) and other piers on the loch.' Garenlochhead pier was closed in 1939 on the outbreak of war.

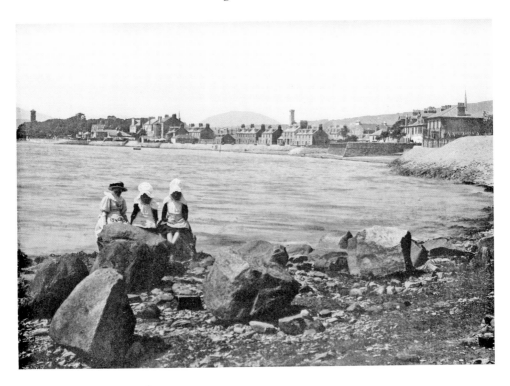

Above: Garelochhead in an illustration from a part-work of photos entitled 'Round the Coast' and published by George Newnes Ltd in 1895. The caption states 'Gareloch-Head is a delightful little town with a great number of handsome villas, and a railway station of its own on the West Highland Railway'.

Right: An LNER July/August 1938 timetable page featuring an afternoon excursion from Rothesay and Dunoon to the Gareloch. This trip used scheduled sailings, changing at Craigendoran in each direction.

Afternoon Excursion to the Gareloch

(ROSNEATH, CLYNDER or GARELOCHHEAD)

" A most enjoyable outing."

At Rosneath, the ruins of the ancient Church of St Modan may be visited, and the great silver fir trees, known as Adam and Eve, are within a short distance of the Pier. These are claimed to be the largest trees of their kind in Great Britain. Rosneath is one of the few sylvan spots on the Clyde Coast which retain the full glory of their pristine beauty.

Clynder is a thriving modern village which well repays a visit. In the district are well-known boat-yards, where many famous sailing and motor yachts have been built.

Nestling at the top of the Loch is the delightful village of Garelochhead. It is a favourite holiday haunt, with an environment full of interest to visitors.

About three hours may be spent on shore at any of the Gareloch Piers.

FROM	Leave	Arrive back	Return Fare (Saloon).
	p.m.	p.m.	s. d.
DUNOON	1 0	5 10 or 7 30	2 0
ROTHESAY	12 15	5 55 or 8 45*	2 9

Passengers change steamers at Craigendoran.

* Passengers change to L M S steamer at Dunoon, except on Saturday, when arrival time at Rothesay is 8-15 p.m.

11

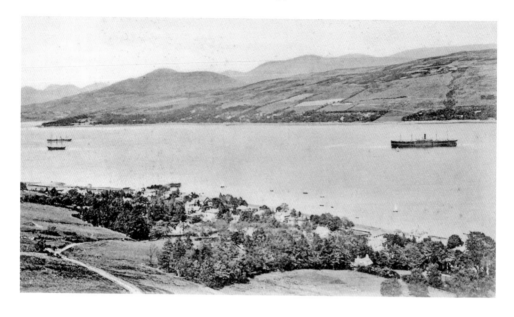

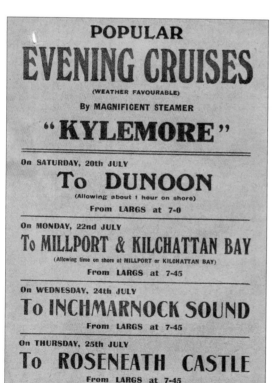

POPULAR
EVENING CRUISES
(WEATHER FAVOURABLE)

By MAGNIFICENT STEAMER

"KYLEMORE"

On SATURDAY, 20th JULY

To DUNOON
(Allowing about 1 hour on shore)
From LARGS at 7-0

On MONDAY, 22nd JULY

To MILLPORT & KILCHATTAN BAY
(Allowing time on shore at MILLPORT or KILCHATTAN BAY)
From LARGS at 7-45

On WEDNESDAY, 24th JULY

To INCHMARNOCK SOUND
From LARGS at 7-45

On THURSDAY, 25th JULY

To ROSENEATH CASTLE
From LARGS at 7-45

Cruise Fare - - - 1/6

John Williamson & Co., 308 Clyde Street, Glasgow, C.1

Above: On the west side of the Gareloch was the village of Clynder, seen here in the foreground. The waters of the Gareloch were used as a lay-up berth for out of use merchant shipping from the early years of the twentieth century, as seen here and also for compass adjustment for newly built ships and those which had been refitted on the Clyde. There were also piers on the west side of the Gareloch at Mambeg and Roseneath.

Left: A handbill from July 1929 for evening cruises by *Kylemore* from Largs, including one to Roseneath Castle. This cruise did not call there, but were merely non-landing trips and had started from Rothesay at 7.00 pm., also calling at Craigmore to pick up passengers.

Loch Long & Loch Goil

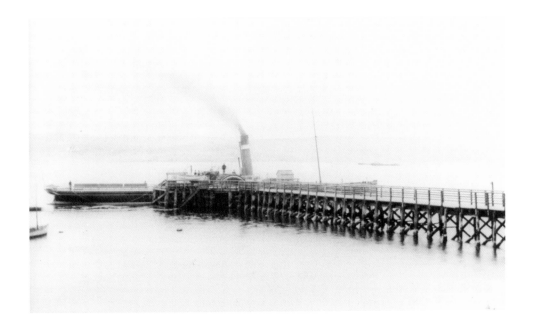

Right: Kilcreggan is one of the last of the traditional piers to survive on the Firth of Clyde, and is served in the summer months by *Waverley*, and by small ferries from Gourock. Kilcreggan Pier celebrated its centenary in 1997.

Below: Kilcreggan Pier between 1883 and 1891 with the NB's *Guy Mannering* berthed at the pier.

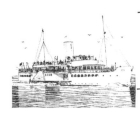

KILCREGGAN STEAMER SERVICES

Mondays to Saturdays, 30 May — 30 September 1970

To and From GOUROCK		To and From DUNOON		To and From ROTHESAY		To and From BLAIRMORE		To and From CRAIGENDORAN		To and From KILMUN	
Leave Kilcreggan	Leave Gourock	Leave Kilcreggan	Leave Dunoon	Leave Kilcreggan	Leave Rothesay	Leave Kilcreggan	Leave Blairmore	Leave Kilcreggan	Leave Craigendoran	Leave Kilcreggan	Leave Kilmun
07 45	08 00	07 45G	07 30G	10 30G	12 20G	11 00	07 25	08*25AG	10 10G	14 10	07 05
08 25	09 15	08 25G	11*05A	13*05A	16*15G	14 10	10 10	10†30AG	10*10A	18 20	09 50
10 30	10 50	10 30G	13 10G	14†35	16†20G	17 10	11 25	11†35A	12*45A		15 50
11 45	13 00E	10*35A	17†10G	17†15		18 20	16 10	19*10A	14†10		
13*05A	14 00	11*45AG	18*35A				17 30		16 50		
13 30E	17 00	13*05A					18*15A				
14†35	18 10	14†35									
16 30	18*55A	17 15									
17 15											
Return Fare 4/9		Return Fare 8/- After 12 00 6/-		Return Fare 14/- After 12 00 10/-		Return Fare 8/- After 12 00 6/-		Return Fare 7/- After 12 00 6/-		Return Fare 8/- After 12 00 6/-	

Cruise to Arrochar via Loch Goil. Ceases after 12 September Tuesdays, Thursdays and Saturdays

OUTWARD				RETURN			
Kilcreggan	leave	10†30G	13*05AG	Arrochar	leave	14†00A	17*00A
Arrochar	arrive	13†25	15*55	Kilcreggan	arrive	17†15A	19*10A

Return Fares to Arrochar — Day, 16/-; Saturday Afternoon, 14/-

3 Lochs Day Tour No. 5. Loch Goil — Loch Long — Loch Lomond. Tuesdays and Thursdays
Ceases after 10 September
Steamer via Loch Goil to Arrochar (Loch Long); Loch Lomond steamer from Tarbet Pier to Balloch Pier; train to Craigendoran thence return by steamer.

OUTWARD			RETURN		
Kilcreggan	Steamer leave	10 30G	Tarbet Pier	Steamer leave	14 35
Arrochar	Steamer arrive	13 25	Balloch Pier	Steamer arrive	15 50
			Balloch Pier	Train leave	16 08
			Craigendoran	Train arrive	16 38
			Craigendoran	Steamer leave	16 50
			Kilcreggan	Steamer arrive	17 15

Passengers find their own way from Arrochar Pier to Tarbet Pier, distance under 2 miles. A privately owned motor coach service runs between these points.

Combined Steamer and Rail Fare from Kilcreggan — 23/-

† Saturdays excepted. A Ceases after 12 September.
‡ Daily until 12 September. Except Tuesday and Thursday thereafter. G Change at Gourock.
* Saturdays only. E Saturdays 19 and 26 September only.
The tickets are valid on the date for which issued and by the services specified

Left: A handbill for sailings from Kilcreggan in summer 1970, incongruously with an illustration of *Maid of the Loch*, timing for the Three Lochs Tour being included.

Below: Kilcreggan, with the pier to the right, seen from Tower Hill in Gourock, with, to the left, Cove, which was served by a pier until the 1930s or earlier. The development of the Victorian villas along the shore can be seen here.

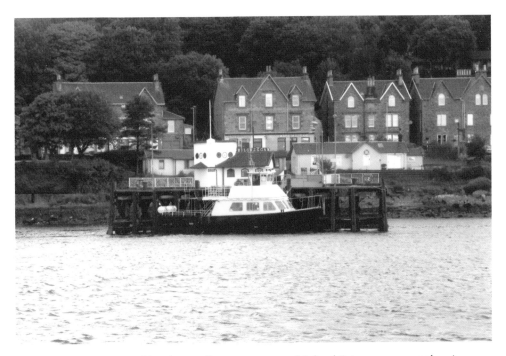

Kilcreggan is now served by the small passenger vessel *Island Princess*, seen at the pier on 7 September 2013.

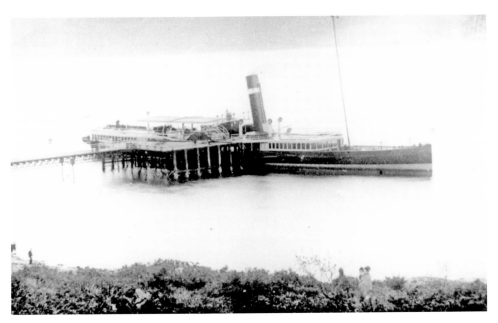

Coulport, five miles north of Cove, was served by a pier in the late nineteenth century, purely used for excursions, as seen here, where *Isle of Arran* has arrived for a special open air concert by the Glasgow Orpheus Choir. It is now the site of a nuclear weapons store for the submarines based in the Holy Loch.

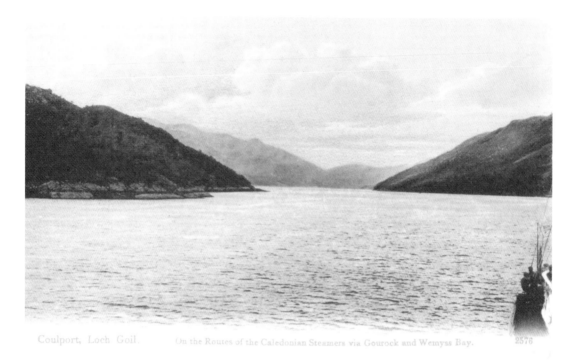

Coulport gives a good view up Loch Goil, seen here in a Caledonian Railway official postcard.

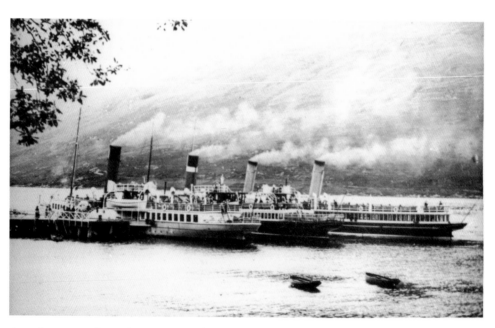

Arrochar was a favourite excursion destination, and in the Edwardian era two, three, and occasionally four steamers could be seen berthed there. Here we see the Glasgow & South Western Railway's *Minerva*, the North British Railway's *Lady Rowena* and the Caledonian Railway's *Ivanhoe*, in a photo taken prior to 1903.

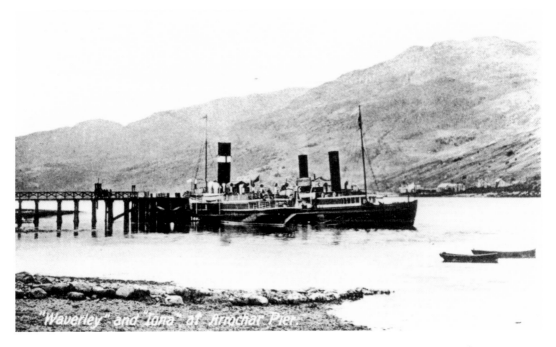

Arrochar between 1922 and 1927, with *Waverley*, on the Craigendoran service, and *Iona*, on MacBrayne's Lochgoilhead mail service at the time, which had been extended to Arrochar.

Arrochar Pier was served by the North British and LNER steamers, with a regular service from Craigendoran by the steamer *Marmion*, seen here in 1938 with a grey hull.

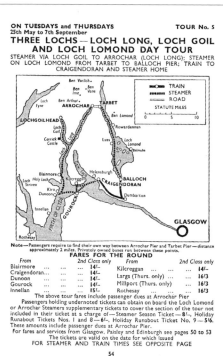

ON TUESDAYS and THURSDAYS TOUR No. 5
25th May to 7th September
THREE LOCHS — LOCH LONG, LOCH GOIL
AND LOCH LOMOND DAY TOUR
STEAMER VIA LOCH GOIL TO ARROCHAR (LOCH LONG); STEAMER
ON LOCH LOMOND FROM TARBET TO BALLOCH PIER; TRAIN TO
CRAIGENDORAN AND STEAMER HOME

Note—Passengers require to find their own way between Arrochar Pier and Tarbet Pier—distance
approximately 2 miles. Privately owned buses run between these points.

FARES FOR THE ROUND

From	2nd Class only	From	2nd Class only
Blairmore	14/-	Kilcreggan	14/-
Craigendoran...	14/-	Largs (Thurs. only) ...	16/3
Dunoon	14/-	Millport (Thurs. only) ...	16/3
Gourock	14/-	Rothesay	16/3
Innellan	15/-		

The above tour fares include passenger dues at Arrochar Pier
Passengers holding undernoted tickets can obtain on board the Loch Lomond
or Arrochar Steamers supplementary tickets to cover the section of the tour not
included in their ticket at a charge of—Steamer Season Ticket—8/-, Holiday
Runabout Tickets Nos. I and 8—6/-, Holiday Runabout Ticket No. 9—5/6.
These amounts include passenger dues at Arrochar Pier.
For fares and services from Glasgow, Paisley and Edinburgh see pages 50 to 53
The tickets are valid on the date for which issued
FOR STEAMER AND TRAIN TIMES SEE OPPOSITE PAGE
54

Arrochar was on the route of the popular
Three Lochs Tour, which was by steamer to
Arrochar one way, and the other by steamer
down Loch Lomond.

ON TUESDAYS AND THURSDAYS TOUR No. 5
25th May to 7th September
(For route map and fares see opposite page)

THREE LOCHS — LOCH LONG, LOCH GOIL
AND LOCH LOMOND DAY TOUR
STEAMER AND TRAIN TIMES
(See important notice on inside cover page)

LOCH GOIL AND LOCH LONG STEAMER

									am
Craigendoran	leave	10 10
Kilcreggan	"		10A15
Gourock	"		10 40
Rothesay	"		10B10
Innellan	"		10B35
Millport (Old Pier)	"			9E25
Largs	"		10E 0
Dunoon	"		11 5
Blairmore	"		11 20
									pm
Lochgoilhead	"		12 25
Arrochar (Loch Long)	arrive			1 25

LOCH LOMOND STEAMER

									pm
Tarbet	leave	2 40
Balloch Pier	arrive	3 55

TRAIN

									pm
Balloch Pier	leave	4 5
Craigendoran	arrive	4 36

STEAMER

									pm
Craigendoran	leave	4 50
Kilcreggan	arrive	5 15
Gourock	"	5 25
Blairmore	"		6A35
Dunoon	"		5 45
Largs	"		6E50
Millport (Old Pier)	"			7E50L
Innellan	"		6 5
Rothesay	"		6 35

A Change at Gourock. B Change at Dunoon.
E Runs on Thursdays only and passengers change at Dunoon. L Change at Largs.
55

The 1961 timetable for the Three Lochs Tour
from the Clyde Coast Piers, showing the
special train from Balloch to Craigendoran,
which latterly was the only one to use the pier
platform at Craigendoran.

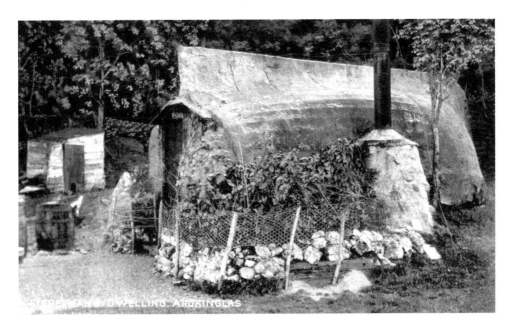

Above: An Edwardian postcard of an old boat serving as a fisherman's cottage at Ardkinglas, on the west side of Loch Long.

Right: An 1835 advertisement for sailings to Lochgoilhead by *Lochgoil*, with connecting coach to Inveraray, and to Arrochar by *St Catherine*, with what may be the first mention of the Three Lochs Tour.

INVERARAY,
ARROCHAR,
LOCHLOMOND, &c.

THE LOCHGOIL

CONTINUES to Ply Daily to and from LOCHGOIL-HEAD, conveying Passengers betw en GLASGOW and INVERARAY as usual.

THE ST. CATHERINE

Will Sail from GLASGOW for ARROCHAR every SATURDAY till further notice, at half-past 3 o'clock afternoon, and on TUESDAYS and THURSDAYS at three quarters past 7 o'clock morning, and on WEDNESDAYS and FRIDAYS at half-past 7 o'clock; leaving Arrochar on Monday morning at 6 o'clock, and on Tuesdays, Wednesdays, Thursdays and Fridays, at 4 o'clock afternoon, so as to admit of Passe gers returning to Glasgow by Lochlong, after having Sailed up Lochlomond in the morning.

25th June, 1835. GRAHAM, PRIN ER

ADVERTISEMENTS. 93

INVERARY VIA LOCHGOILHEAD.

STEAM CONVEYANCE

TO

AND FROM

Glasgow, Greenock, Gourock, Kilcreggan, Cove,
Ardentinny, & Lochgoilhead ;

WITH PASSENGERS TO AND FROM INVERARY.

THE FINE STEAMER,

" BREADALBANE," CAPTAIN GRAHAM,
SAILS FROM GLASGOW BRIDGE
Every Morning at Half-past 8 o'clock.---Train at 9.
FOR GREENOCK, GOUROCK, KILCREGGAN, COVE,
ARDENTINNY AND LOCHGOILHEAD;
Arriving at the latter place about HALF-PAST TWELVE o'clock.

At Lochgoilhead, a First-Class and

COMMODIOUS NEW COACH

Waits the arrival of the "*BREADALBANE,*" conveying Passengers
to ST. CATHERINE'S, a distance of Seven Miles (passing through
Scenery unsurpassed for its wild and romantic grandeur), where there
is a regular Steamboat Communication across Lochfine to INVERARY.
Passengers for GLASGOW, &c., leave INVERARY, per Steamer
"*ARGYLE,*" every Forenoon at 10 o'clock, arriving in GLASGOW about
Half-past 5 p.m.

**The whole distance is accomplished between Glasgow
and Inverary in Six Hours.**
Passengers from INVERARY, &c., for EDINBURGH, can arrive there
at Half-past 7 p.m.

Between INVERARY and OBAN there is a Daily Coach Communi-
cation, leaving both places at 9 Morning.

PLEASURE PARTIES

Going and Returning same day from Glasgow, Greenock, or Gour-
ock, to Kilcreggan, Cove, Ardentinny, or Lochgoilhead,
charged only One Fare.

FARES:

From GLASGOW to LOCHGOILHEAD,Cabin, 2s. 0d.; Steerage, 1s. 6d.
 " GREENOCK or GOUROCK to Do.,,, " 1s. 6d.; " 1s. 0d.
GLASGOW, June, 1851.

Left: An 1851 advertisement
for sailings to Lochgoilhead by
Breadalbane, with a connecting coach
to St Catherines on Loch Fyne, and
steamer from there to Inveraray.

Below: Lochgoilhead with the
Lochgoil Company's *Windsor Castle*
berthed at the pier. She ran there from
Glasgow from 1875 until the turn
of the century. Lochgoilhead Pier
continued to be used until July 1965,
with *Maid of Skelmorlie* making the
final call, on the Saturday sailing to
Arrochar.

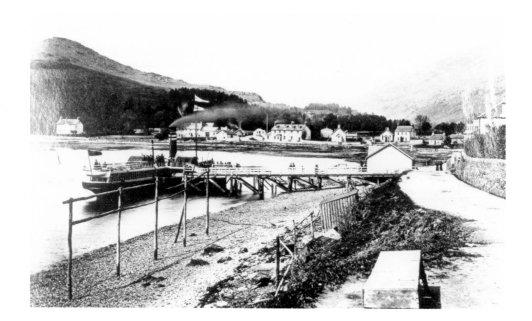

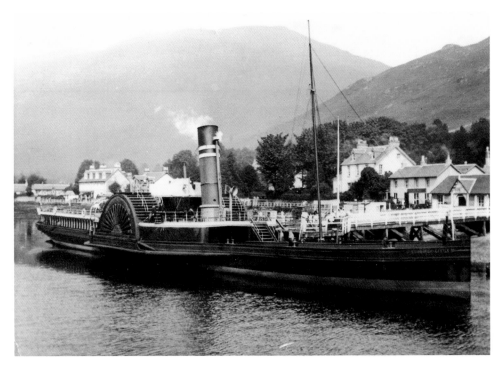

The final Lochgoil paddle steamer *Edinburgh Castle*, which operated on the route from Glasgow from 1879 until 1912 and is seen here at Lochgoilhead.

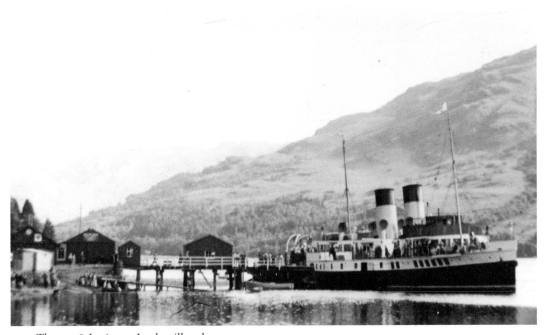

The 1938 *Jupiter* at Lochgoilhead.

PLEASURE SAILINGS FROM GLASGOW (Bridge Wharf: SOUTH SIDE)

EVERY DAY (Including Sundays)
TO
DUNOON, ROTHESAY and KYLES OF BUTE

by T.S. "QUEEN MARY II" (or other steamer)
Ceases after 23rd September

OUTWARD				RETURN			
			a.m.				p.m.
Glasgow (Bridge Wharf)	...	leave	11 0	Tighnabruaich (Kyles of Bute) leave			3 55
Gourock ,,		1SX0p	Rothesay ,,		4 45
Dunoonarrive		1 20	Dunoon ,,		5 25
Rothesay ,,		2 10	Gourockarrive		5D 50
Tighnabruaich (Kyles of Bute)	,,		2 55	Glasgow (Bridge Wharf)	... ,,		7 35
	SX—Not on Saturdays or Sundays. D—Change at Dunoon.						

	RETURN FARES TO		
FROM	DUNOON	ROTHESAY	KYLES OF BUTE
Glasgow (Bridge Wharf) ...	★7/6	★8/6	★12/-
Gourock	2/9	5/-	6/6
Dunoon	—	3/9	5/6
Rothesay	—	—	3/9

The tickets are valid on the date for which issued except those marked ★ which
are valid for three calendar months.

SUNDAY AFTERNOON CRUISE
TO
DUNOON and LOCHGOILHEAD

(allowing time ashore)

by P.S. "JUPITER" (or other steamer)

30th June until 25th August

OUTWARD			RETURN		
		p.m.			p.m.
Glasgow (Bridge Wharf) ... leave		2 15	Lochgoilhead leave	6 10
Dunoon ,,	4 30	Dunoon ,,	7 25
Lochgoilhead	...arrive	5 40	Glasgow (Bridge Wharf)	...arrive	9 40

CRUISE FARES TO

DUNOON	LOCHGOILHEAD
7/6	9/6

Cruise Fare from Dunoon 4/3

In 1957 the 1937 *Jupiter* ran a Sunday afternoon cruise from Glasgow and Dunoon to Lochgoilhead.

284. LOCHGOILHEAD via WHISTLEFIELD (Motor Launch).

Weekdays a Motor Launch will be available for passengers *en route* to Lochgoilhead arriving at Whistlefield if intimation be sent to ctor Blair, Lochgoilhead, either by telegraph or by letter.

An extract from the 1937/38 LNER timetable with details of a motor launch service from Portincaple, connecting with West Highland Railway trains at Whistlefield station, to Lochgoilhead.

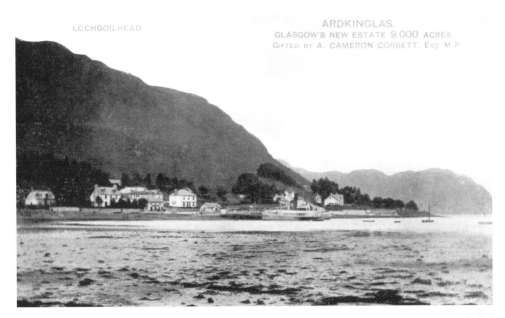

An Edwardian postcard of Lochgoilhead, described by a NBR Guidebook as a 'sweetly secluded and restful spot'.

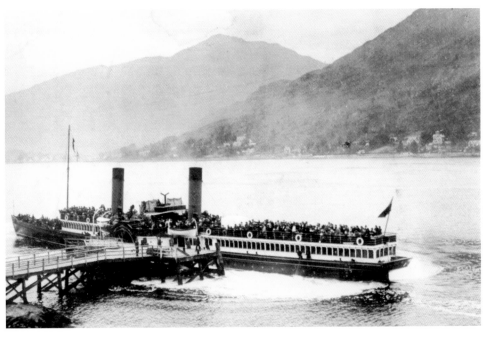

On the west side of Loch Goil was Douglas Pier, seen here with *Iona* berthed during the period when she was on the Loch Goil mail service for MacBraynes. It was closed in 1942 and was taken over by the Navy in connection with submarine testing. Douglas Pier had two calls in recent years, one in 1989 by MV *Pioneer* with HRH Princess Anne on board, and one in 1997 by PS *Waverley* in her Golden Jubilee year.

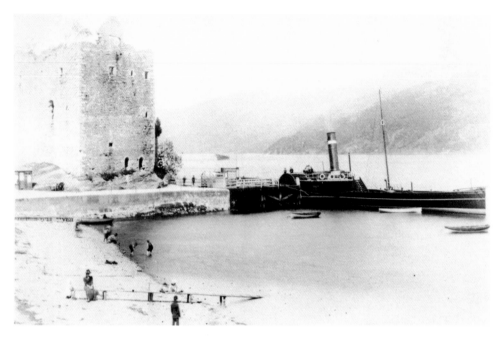

Carrick Castle served the village of that name with its ruined castle, now rebuilt and inhabited. The pier is seen here with Captain Buchanan's *Elaine* in the late nineteenth century.

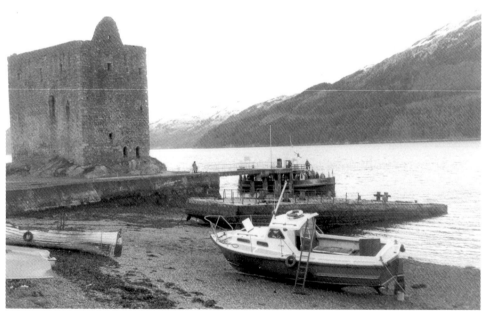

Carrick Castle Pier was closed on the outbreak of war in 1939. A smaller structure was built for the Admiralty, and this has been used for smaller vessels, such as Clyde Marine's *Kenilworth* on a PSPS Cruise in the late 1970s. Carrick Castle Pier is now totally closed and is unlikely ever to be used again.

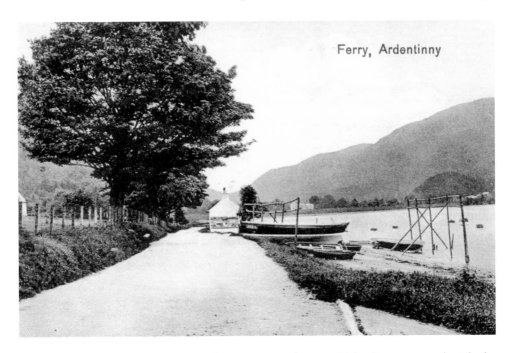

Ferry, Ardentinny

Ardentinny had a ferry service until 1928 to Coulport, which also connected with the Lochgoilhead steamers, seen here in a postcard view posted from there in 1924.

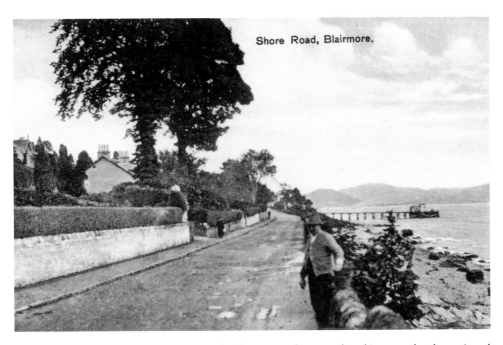

Shore Road, Blairmore.

Blairmore, another village of Victorian villas, has a pier that was closed in 1979, but has enjoyed a renaissance in recent years, reopening in 2005 after restoration by Blairmore Pier Trust, and is now a regular port of call for *Waverley*.

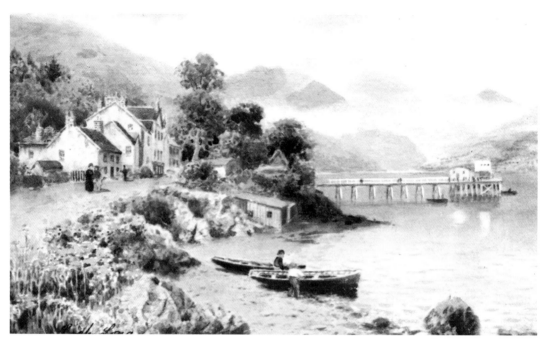

A Tuck's *Oilette* postcard of Blairmore in the Edwardian era.

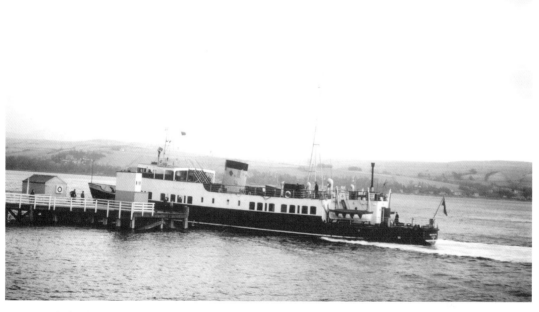

Maid of Ashton at Blairmore on 1 January 1967.

The Holy Loch

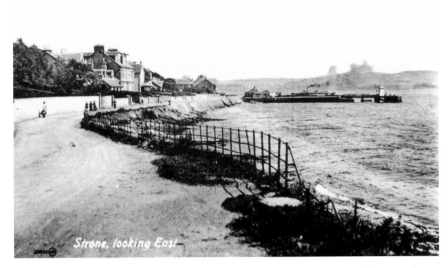

Strone, looking East

Strone Pier was at the entrance to the Holy Loch, on the northern shore, and was closed in 1956. It was a call on the Holy Loch service, serving a small community there.

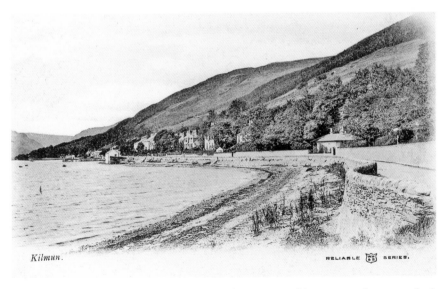

Kilmun.

RELIABLE SERIES.

Kilmun church is on the site of one endowed in 1442, and has a mausoleum attached, which is the burial place of the Dukes of Argyll. Land at Kilmun was purchased by David Napier in 1827, and a pier, hotel and some houses were built. A through service was operated to Inveraray by coach to the foot of Loch Eck, by the small steamer *Aglaia* on Loch Eck, by coach to Strachur, and by steamer from there.

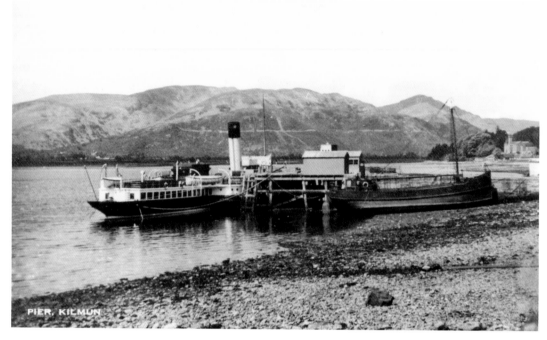

Duchess of Fife at Kilmun Pier with a puffer beached alongside it, in a 1930s postcard view.

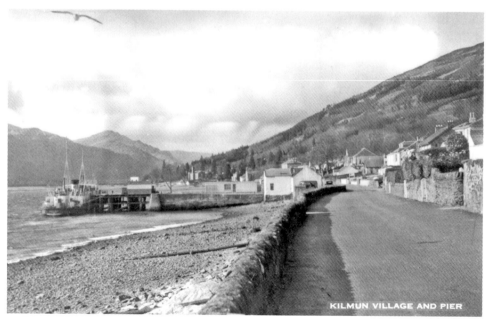

Maid of Ashton berthed at Kilmun Pier in a 1950s postcard view. She maintained the service from Gourock to Kilmun from her building in 1953 until May 1967, and lay at Kilmun Pier each night.

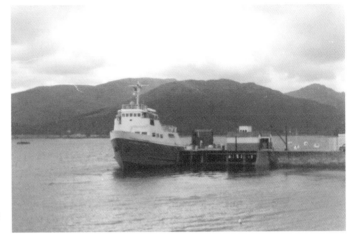

Kilmun Pier was closed in 1971, but has remained virtually intact and is used as a lay-by berth for Western Ferries vessels. Their *Sound of Islay* is seen here at the pier in the late 1970s.

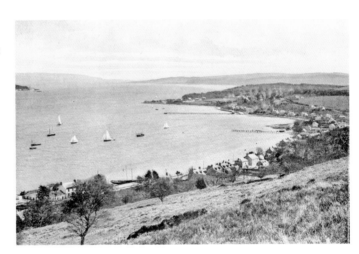

The twin villages of Ardnadam and Sandbank lie on the south shore of the Holy Loch. Both had long piers extending into the shallow waters of the south side of the Holy Loch, with Ardnadam being the nearer in this view. Both piers closed in 1939 and Ardnadam Pier has been restored with new pier gates, etc., although the pier head is in poor condition.

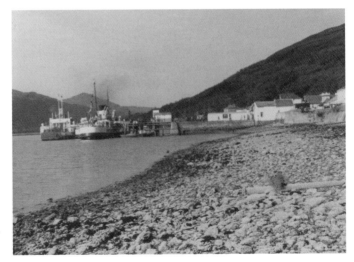

Waverley at Kilmun on a PSPS charter on 15 September 1979 with Western Ferries' *Sound of Sanda* lying outside her.

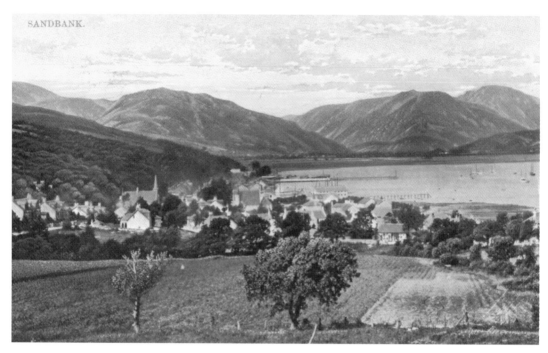

Sandbank developed where the road over the hill from Dunoon met the coast road via Hunters Quay. The village is seen here from the hill behind it in an Edwardian postcard view.

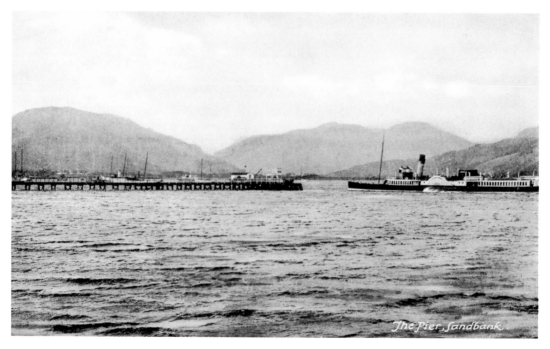

Sandbank Pier with the CSP's *Caledonia* arriving in the 1923–24 'tartan lum' condition, with a tricolour funnel.

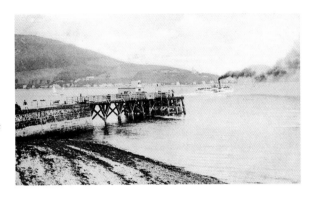

Hunter's Quay, now the terminus of Western Ferries car ferry service from McInroy's Point near Gourock, had a steamer pier, where the GSWR's *Minerva* or *Glen Rosa* is seen departing in this postcard view. The pier ceased to be used by steamer services in 1964.

The Clyde was famous for yacht caring in the late Victorian and Edwardian times, with two large yachts seen here off Hunter's Quay with the pier just visible to the left at the point.

There is one large yacht to be seen in the Firth nowadays, *Drum*, owned by Sir Arnold Clark and used for corporate hospitality. She is seen here on 7 September 2013, off Cove.

Kirn, Dunoon and Innellan

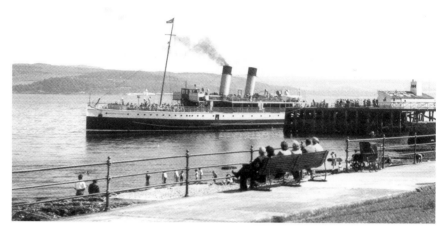

Kirn is half way between Hunter's Quay and Dunoon and was often a call for Clyde steamers prior their call at Dunoon, a practice that continued, on some sailings, into the car ferry era. The turbine steamer *Duchess of Argyll* is seen there in post-1948 condition with a wheelhouse. The pier ceased to be used in 1964.

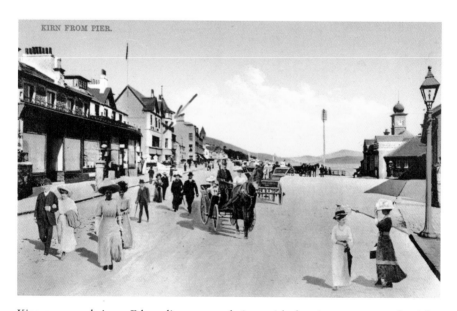

Kirn promenade in an Edwardian postcard view, with the pier entrance to the right, and an arrow pointing to an upstairs window in a building to the left, probably to mark the bedroom in somebody's guest house or hotel.

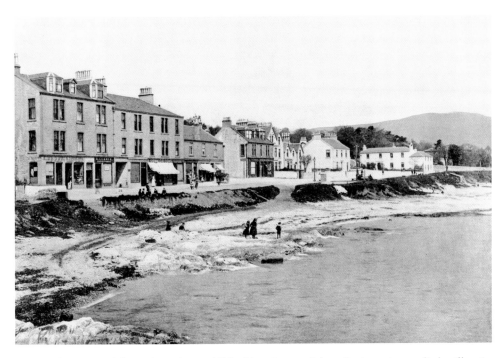

Kirn with its row of shops, in a view published in 1895, and described as a 'quant little village'.

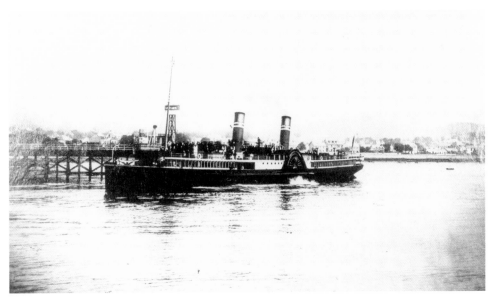

Dunoon is the largest town on the Cowal Peninsula, and is largely a Victorian creation. McPhun's Scottish Tourist Steam-boat pocket guide, published in 1848, states, 'In the town of Dunoon itself, there is little to interest the tourist, except its fine and diversified sea-ward views'. Dunoon developed as a resort after the first pier was built in 1835. *Lord of the Isles* of 1877 is seen here at Dunoon pier, while still with a single berth pier, prior to being rebuilt in 1895.

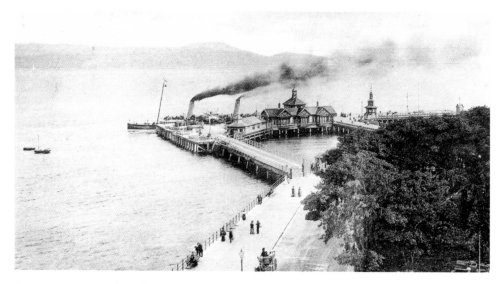

Dunoon Pier in an Edwardian postcard, posted in 1904, with the CSP's *Galatea* berthed, showing the two arms reaching it, the left of which was used for vehicle traffic from the advent of the car ferries in the 1950s, up until the cessation of the car ferry service in 2011.

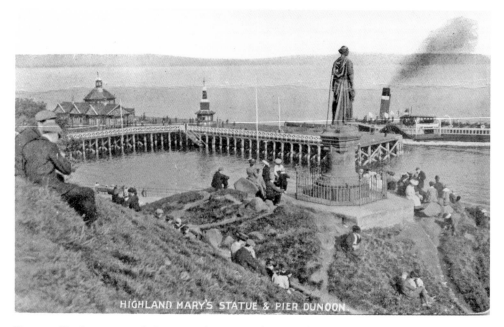

Dunoon Pier in a postcard view posted in 1907, showing the NB's *Talisman* berthing. The area around the statue of Highland Mary above the pier, erected in 1842, has attracted a large number of visitors. Mary Campbell, known as Highland Mary (1764–86) was one of Robert Burns' sweethearts. This was the site of Dunoon Castle, possibly dating to the sixth century, which was abandoned after a massacre of the Lamonts of Argyll at Toward Castle by the Campbells in 1646. The surviving Lamont men were brought to Dunoon and hanged from a tree in front of the church. It is said that when the tree was cut down, its roots gushed blood.

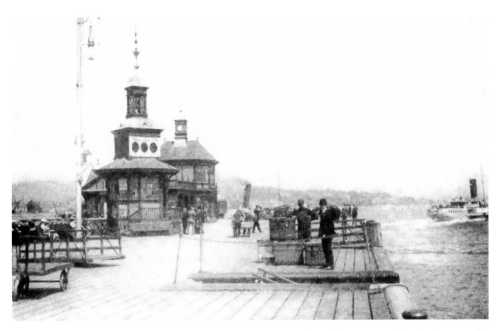

Dunoon Pier *c.* 1900 with a GSWR steamer departing, and another steamer berthed across the north end.

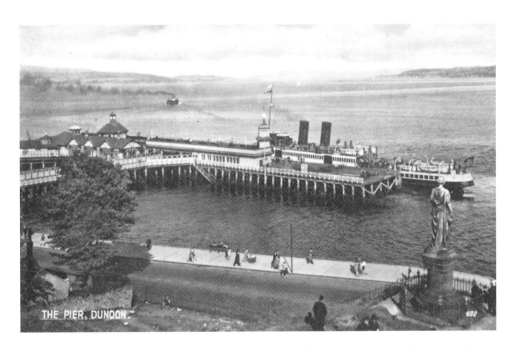

In 1937 the first pier Tannoy system on the firth was installed and an upper deck promenade was added to the pier, seen here with MacBrayne's *King George V* berthed, when she was relieving *Saint Columba*, in 1946, when the latter was being reconditioned after war service, and *KGV* was on the Ardrishaig mail service all summer.

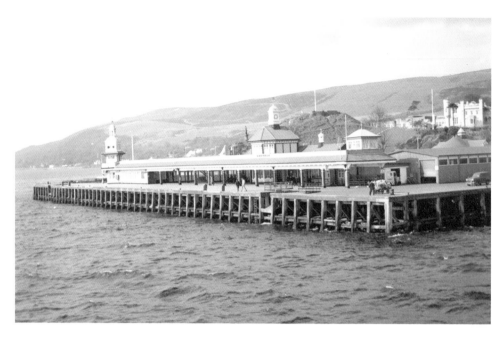

Dunoon Pier in the 1960s from the sea. Sadly the pier is now almost derelict, with the upper deck having been removed around 1980 and the southerly berth half-demolished and fenced off. The pier has recently been given a few million pounds to assist in its restoration.

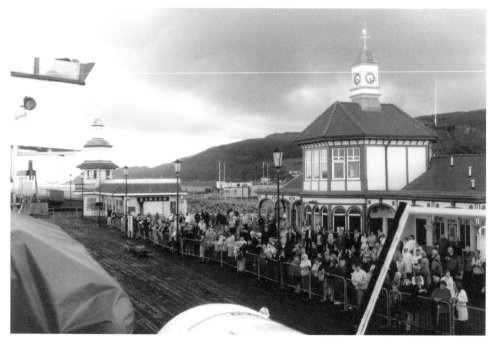

Dunoon Pier on the final day of vehicle ferry service, 29 June 2011. Note the barriers keeping people back from the edge of the pier.

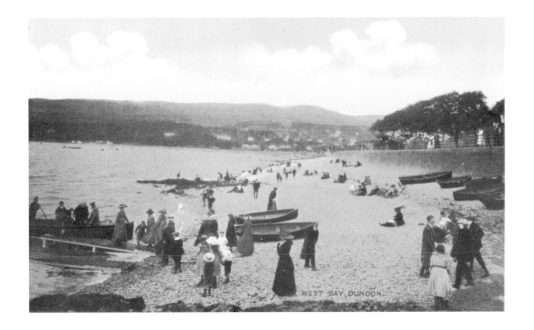

Right: The handbill for evening cruises by the then new *Jeanie Deans* from Craigendoran and Helensburgh to a firework display in the Castle Gardens, Dunoon, in August 1931.

Below: Dunoon had a bathing beach in the West Bay, south of the pier, with rowing boats for hire.

Fireworks Display

IN

DUNOON
CASTLE GARDENS

ON

SATURDAYS
15th and 29th August

STEAMERS WILL SAIL TO DUNOON

From Helensburgh
6.40 P.M. and 8.0 P.M.

From Craigendoran
6.52 P.M. and 7.50 P.M.

Passengers will have ample time ashore to witness Display of Fireworks, returning from DUNOON PIER at 10.0 p.m. prompt

BY NEW STEAMER
"JEANIE DEANS"

CABIN		STEERAGE
1/9	RETURN FARES	1/5½

Hugh Paton & Sons Ltd., Printers, Edinburgh ·L·N·E·R· *July* 1931 (S.C. 2268) (5-M)

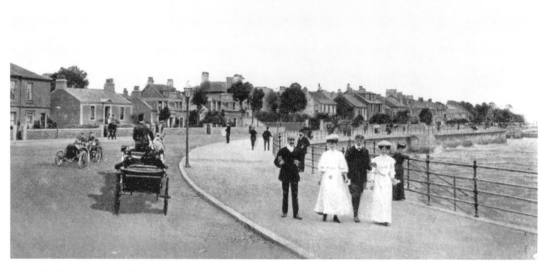

The East Bay, north of Dunoon Pier, with holidaymakers promenading in all their Edwardian finery and a new-fangled car, on a postcard posted in August 1918.

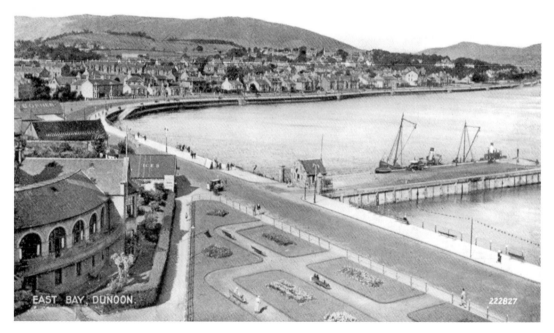

Dunoon's East Bay with a couple of puffers berthed at the coal pier, where *Waverley* was berthed after her contretemps with the Gantocks in 1977.

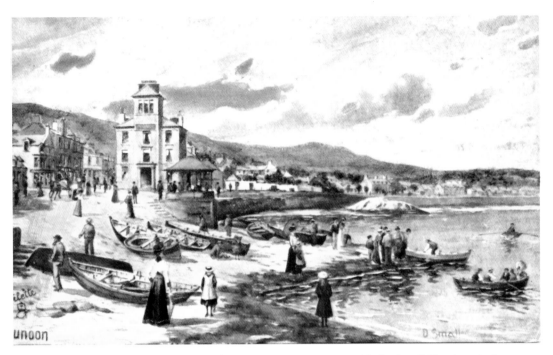

A Tuck's Oilette postcard of rowing boats in Dunoon East Bay with the Argyll Hotel, again from the 'Clyde Watering Places' series.

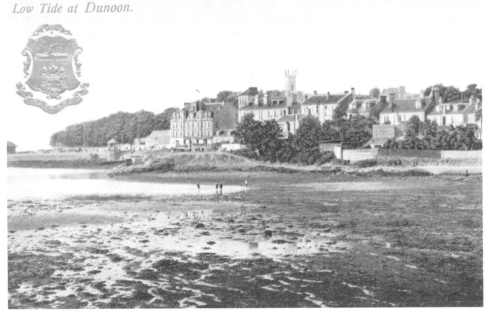

A postcard, posted in July 1905, entitled 'Low Tide at Dunoon', with a gilt embossing of the Dunoon Town Council Crest showing a castle and a paddle steamer.

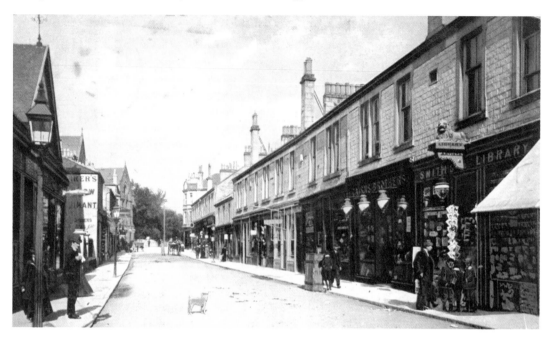

Dunoon's main shopping street, Argyle Street, in a postcard view posted in 1907. It was common for passengers to leave the steamer at Dunoon and spend all day in the pub, staggering back to the steamer in the evening. The view is little changed today, with local businesses still being in the majority.

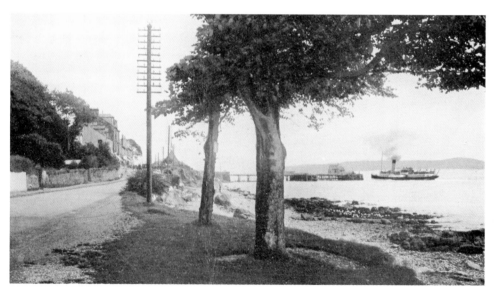

Innellan, a few miles south of Dunoon, was another village served by a steamers' pier. Most of the Gourock and Craigendoran to Rothesay steamer called here, and there was a service from Wemyss Bay as well. It is seen here with the 1892 *Mercury* arriving between 1925 and 1933. The pier was closed in 1972 with the final call being by Waverley. It had a second lease of life for Sir Robert McAlpine, in connection with the oil platform construction yard at Ardyne and was finally closed in 1974.

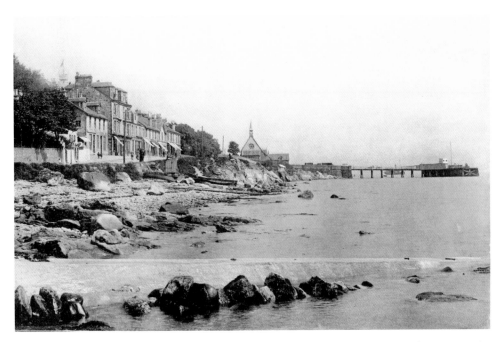

Innellan in a photo published in 1895. The blind minister Revd George Matheson was the incumbent here from 1869 to 1887. He is known as the author of the hymn 'O love that wilt not let me go', written many years after his fiancée had broken off the engagement because he was going blind, when his sister, who had looked after him, had got married and he was left on his own.

Opposite Rothesay on the Cowal shore was the Ardyne oil platform construction yard, served from Rothesay by the motor vessel *Bournemouth Queen*, later renamed *Queen of Scots* (p.13), and other vessels, and visited once by *Waverley* on a PSPS charter, seen here, on 15 September 1979.

The Kyles of Bute

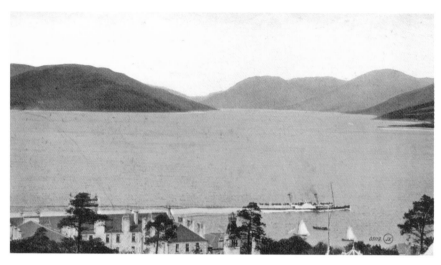

Loch Striven, seen here in a postcard view from the Glenburn Hotel in Rothesay with *Ivanhoe* passing in the foreground, was occasionally visited by Clyde Steamers making non-landing afternoon and evening cruises.

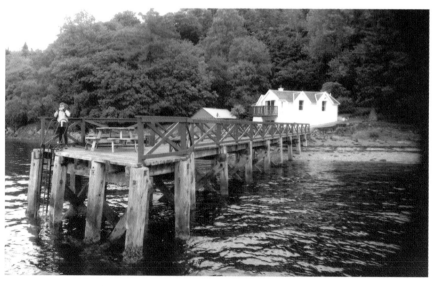

Berry's Pier, on Loch Striven, was a privately owned pier in the Glenstriven estate of Leith merchant Walter Berry. It saw occasional calls by Clyde steamers on special trips and evening cruises, but became derelict after the First World War or before. In the late 1990s the current owner of the estate built a small pier, using timbers salvaged from Innellan Pier when it was demolished, and it has seen a couple of calls on enthusiast charters by smaller vessels in recent years.

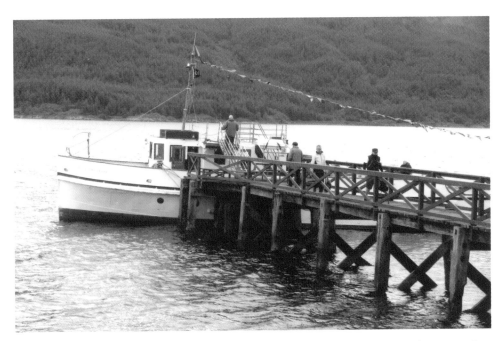

The Second Snark built in 1938, berthed at Berry's Pier on 7 September 2013. There are only a couple of cottages at the landward end of the pier and no road access, some enthusiasts who had arrived to handle the ropes, having cycled there along forest tracks.

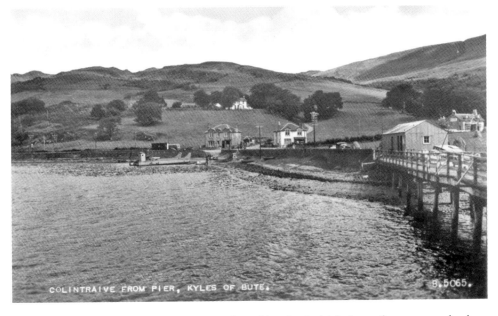

Colintraive had a pier, closed in 1946 and used by the Ardrishaig mail steamer and others heading for the Kyles of Bute. In 1950 a car ferry service commenced to Rhubodach in Bute, and the pioneer car ferry *Eilean Mor* is seen to the left of the pier. As can be seen, Colintraive is a very small community.

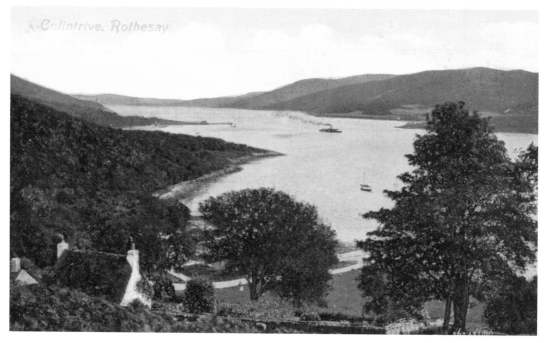

Colintraive, showing its pier, and the western Kyle with a steamer heading towards the Kyles of Bute and Tighnabruaich.

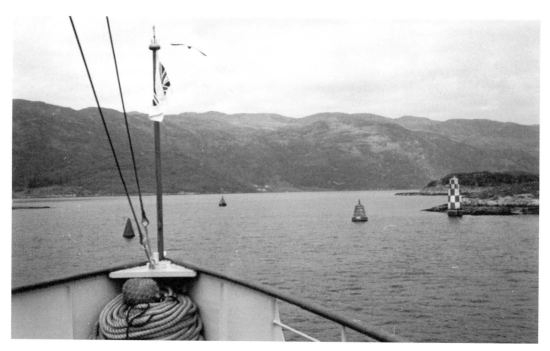

The narrow channel through the Kyles is the highlight of any steamer trip on the Clyde, seen here from Waverley in pre-1967 condition.

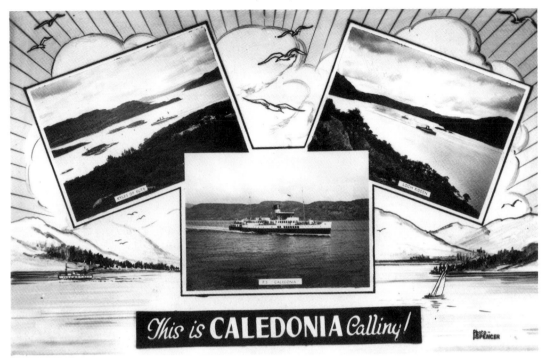

The Kyles of Bute was a favourite destination for evening cruises, like this one on *Caledonia* in the 1940s.

The Kyles of Bute with early torpedo boats passing through, in an Edwardian postcard scene posted in 1903.

Ormidale Pier on Loch Riddon served the communities in Glendaruel, but had no village near the pier. It was closed in 1939 and has seen occasional calls by enthusiast charters by smaller vessels in recent years, like this by *Countess of Breadalbane* in 1964 on a CRSC charter.

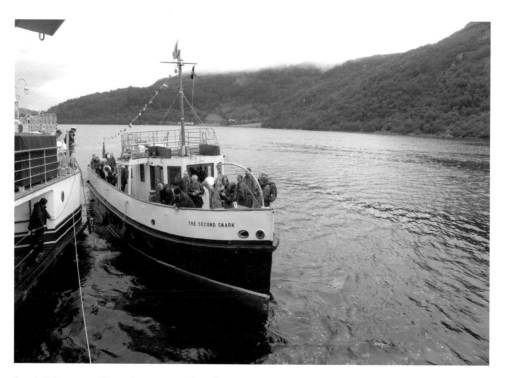

On 8 July 2012, *Waverley* was tendered at Ormidale by *The Second Snark*, whilst on a joint CRSC/PSPS/CCA charter.

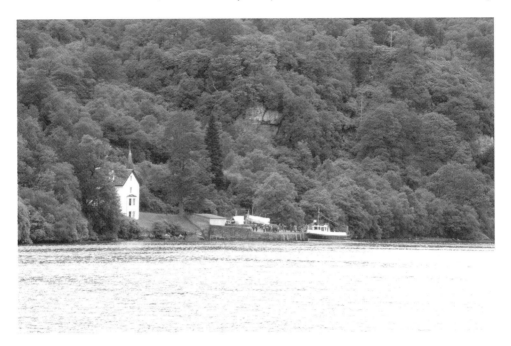

The Second Snark moored at Ormidale on 8 July 2012, showing the inhospitable surroundings of the pier.

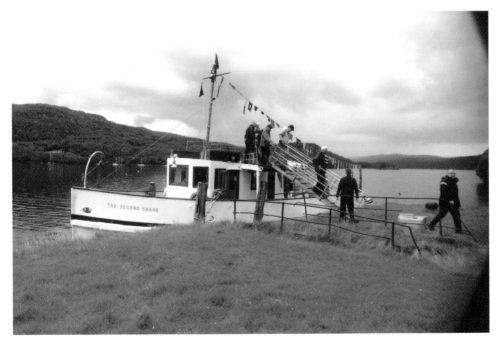

The Second Snark now with a white hull at Ormidale on 7 September 2013 on a Coastal Cruising Association charter.

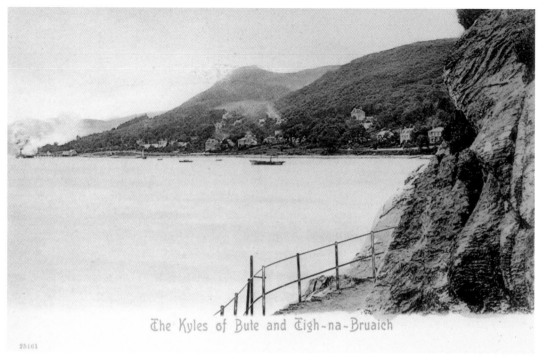

The Kyles of Bute and Tigh-na-Bruaich

Tighnabruaich is the first village on the East Kyle, and is seen here in an Edwardian postcard view with a steamer berthed at the pier., emitting copious amounts of smoke.

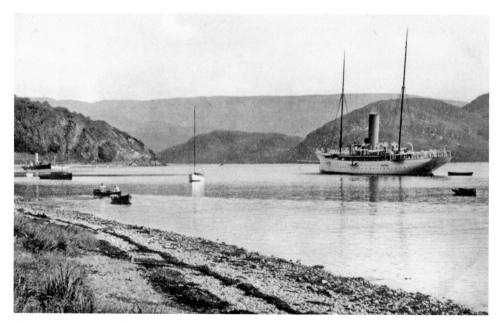

Tighnabruaich was a favoured mooring point for steam yachts in the early years of the twentieth century.

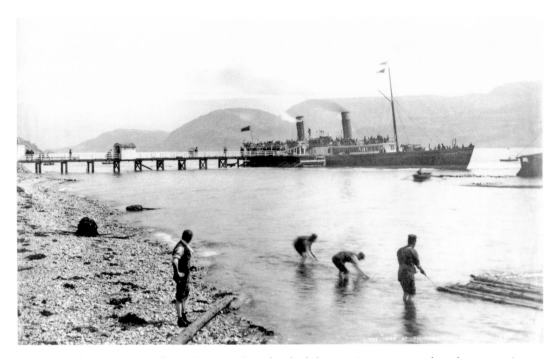

Tighnabruaich Pier with MacBrayne's *Iona* berthed there, prior to 1871, when the steamer's funnels were lengthened.

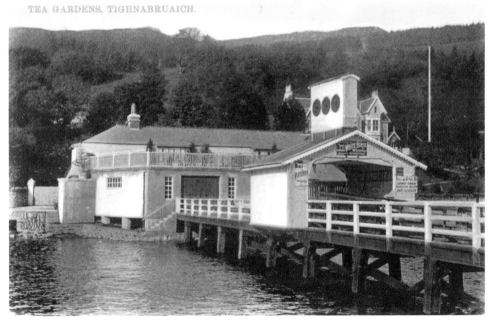

Tighnabruaich is the only surviving pier in the Kyles of Bute area, seen here in an Edwardian postcard view.

Left: Tighnabruaich pier in the early 1960s.

Below: Tighnabruaich pier with MacBrayne's *Columba* of 1878 berthed, and Buchanan's *Isle of Arran* off the pier.

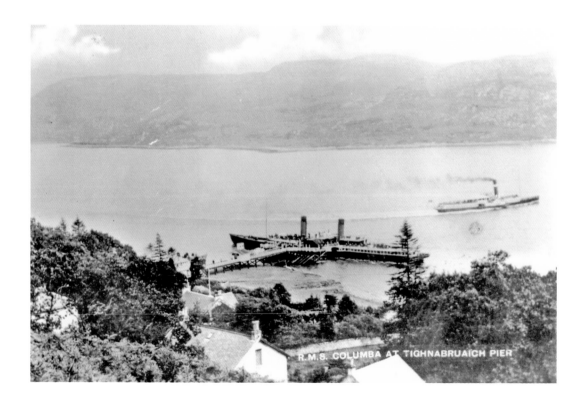

R.M.S. COLUMBA AT TIGHNABRUAICH PIER

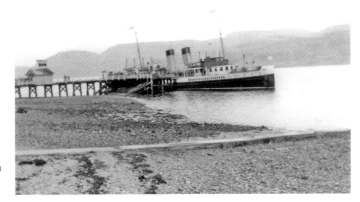

Jeanie Deans at Tighnabruaich in the late 1950s.

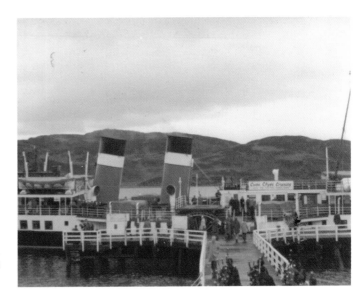

Waverley at Tighnabruaich in the late seventies, prior to the removal of her starboard aft lifeboat, seen from the terrace behind the pier buildings with a pipe band heading down the pier towards her.

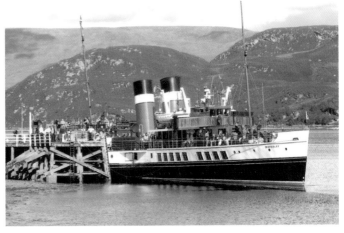

Waverley berthed at Tighnabruaich in her post-rebuild condition, after 2000. This view must have been captured countless thousands of times by passengers on their brief time ashore here. The pier is now part of a trust, although still remaining the property of Argyll and Bute council.

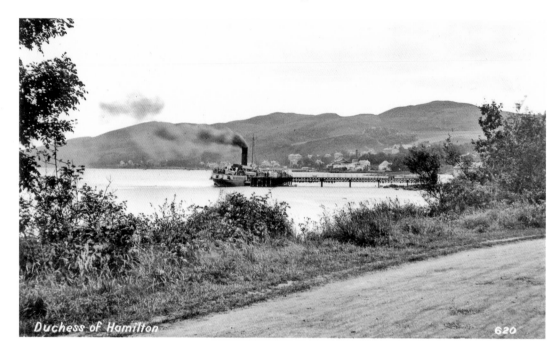

A mile or so beyond Tighnabruaich is Auchenlochan, where the pier closed in 1948. The GSWR's *Juno* is seen there in a postcard view erroneously captioned, '*Duchess of Hamilton*'.

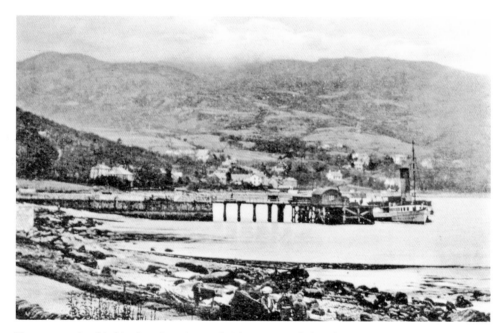

Kames was the third in the triumvirate of Kyles piers and closed in 1928, and is seen here with the GSWR steamer *Mercury* berthed in a pre-1914 view.

POPULAR
EVENING CRUISES
PER MAGNIFICENT STEAMER
"KYLEMORE"
(Weather favourable)

On MONDAY, 29th JUNE
To KAMES (Kyles of Bute)
(Time on Shore)
From Rothesay 7-0, Craigmore 7-5, Port-Bannntyne 7-15

On THURSDAY, 2nd JULY
To DUNOON and HELENSBURGH
(Allowing time on Shore at Dunoon or Helensburgh)
From Rothesay 7-0, Craigmore 7-5

On FRIDAY, 3rd JULY
To KYLES OF BUTE (LANDING AT ORMIDALE)
From Rothesay 7-0, Craigmore 7-5, Port-Bannatyne 7-15

Music on Board

Cruise Fares—
KYLES PORTS or DUNOON - - 1/6
HELENSBURGH - - 2/-
JOHN WILLIAMSON & Co., 99 Gt. Clyde Street, Glasgow, C.1

Kames was also a destination for evening cruises, as seen in this handbill from 1925, which also features a trip landing at Ormidale, both from Rothesay, Craigmore and Port Bannatyne by *Kylemore* following her daily trip up-river to Glasgow.

Loch Fyne

Kyles of Bute and Otter.

Going via TIGHNABRUAICH, and Coach to OTTER, returning by "Lord of the Isles," or vice versa.

	a.m.		a.m.
GLASGOW (St. Enoch)............lev.	8 30	GLASGOW (St. Enoch)......lev.	8 30
Paisley (Canal) ,,	8 44	Paisley (Canal)............ ,,	8 44
Greenock (Princes Pier)arr.	9 10	Greenock (Princes Pier)....arr.	9 10
Do. do. Steamer lev.	9 10	Do. do. Steamer lev.	9 10
Tighnabruaich............. ,, arr.	11 5	Otter........... ,, arr.	12 20
Do. Coach lev.	11 15	Do.Coach lev.	*2 30
Otter................... ,, arr.	1 30	Tighnabruaich...... ,, arr.	4 40
Do.Steamer lev.	3 30	Do.Steamer lev.	4 50
Greenock............ ,, arr.	6 40	Greenock ,, arr.	6 40
Do. (Princes Pier)........lev.	6 50	Do. (Princes Pier)...lev.	6 50
Paisley (Gilmour Street)........arr.	7 21	Paisley (Gilmour Street)....arr.	7 21
GLASGOW (St. Enoch).......... ,,	7 39	GLASGOW (St. Enoch)...... ,,	7 39

Coach may leave earlier at discretion of Coachman.

FARES FOR THE ROUND (including Coachman's Fee)—

Glasgow and Paisley. .. 1st Class and Steamer, 11/6 ; 3rd Class and Steamer, 10 6.

The timetable for a tour to Otter Ferry, outward by steamer to Tighnabruaich, thence by coach, returning by *Lord of the Isles*, from the June 1901 GSWR steamer timetable.

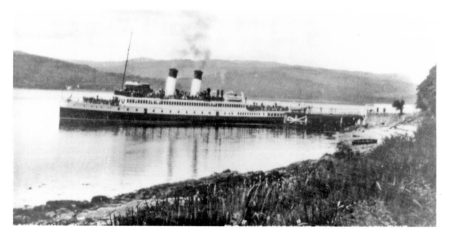

Strachur was a port of call for the Inveraray steamers, including those operated by Turbine Steamers Ltd. *King George V* is seen there between 1929 and 1935. It was here that there was a connection with the coach which connected with the Loch Eck steamer *Fairy Queen*, from 1878 until 1929, which itself connected with the coach from Kilmun or Dunoon. Following the withdrawal of *Fairy Queen*, a bus connection with Dunoon was maintained from 1929 until the pier closed in 1935. Strachur Pier was blown up in 1983 and no wooden part of it has survived.

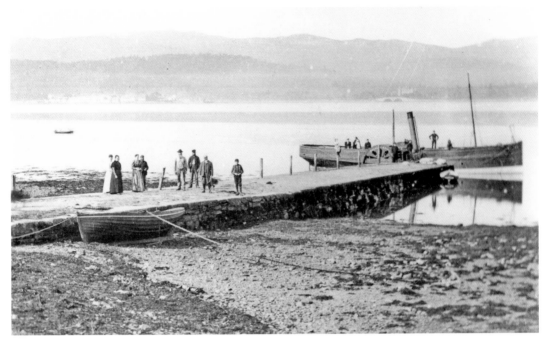

The Inveraray to St Catherine's ferry *Fairy* of 1893 at the small pier at St Catherine's. From here a coach connected with Lochgoilhead through Hell's Glen. She operated on this service until wrecked in 1912.

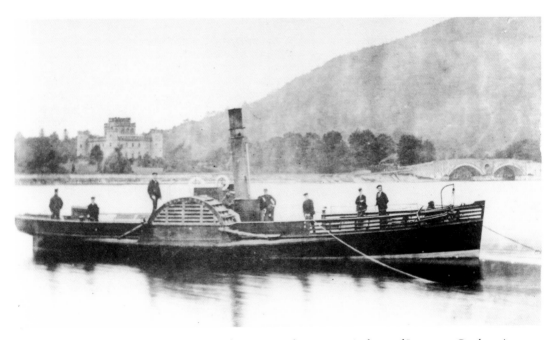

An earlier Inveraray to St Catherine's ferry, *Fairy* of 1865, seen in front of Inveraray Castle, prior to the addition of a third floor and spires to the towers following a fire in 1877.

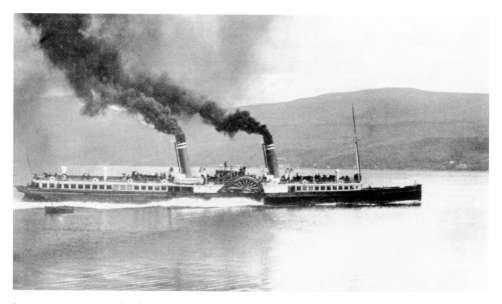

Inveraray was a popular destination in the early and mid-nineteenth century, but it was not until the advent of the first *Lord of the Isles* in 1877 that a day trip there was possible from Glasgow. This is the second *Lord of the Isles* in 1891, steaming furiously in Loch Fyne early in her career prior to the upper deck being extended to the bow.

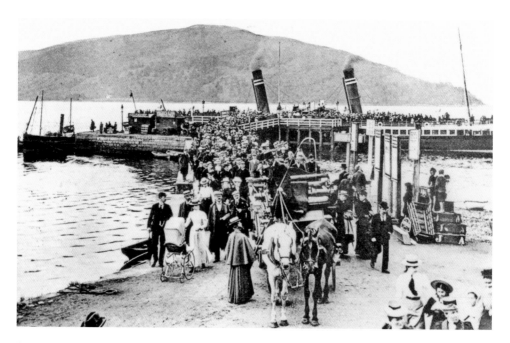

Passengers streaming ashore from the 1891 *Lord of the Isles* at Inveraray, with the second *Fairy* at the left-hand end of the pier. The pier remained in regular use by steamers until 1973 and has been used occasionally since then. *Waverley* made her last call in 2003 and the pier was condemned in 2013.

NEW ROUTES TO THE WEST HIGHLANDS.

GLASGOW,
INVERARAY AND OBAN,
Via Greenock, Wemyss Bay, and Kyles of Bute.

The Splendid Saloon Steamer
"LORD OF THE ISLES,"
(Speed 25 miles an hour),

SAILS DAILY from GREENOCK (Custom House Quay) at 8.15 a.m., Prince's Pier at 8.30 a.m., for KIRN, DUNOON, WEMYSS BAY, ROTHESAY, KYLES OF BUTE, STRACHUR, and INVERARAY, connecting with the undernoted Trains at Greenock and Wemyss Bay:—

From GLASGOW (St Enoch), via Greenock (Princes Pier),at 7.25 a.m.
Do. (Central and Bridge St.), via Greenock,......at 7.30 a.m.
Do. (Bridge St.), via Wemyss Bay,.................at 8.10 a.m.
From EDINBURGH (Princes Street), via Wemyss Bay,........at 6.40 a.m.

Returning from Inveraray at 2 p.m., and Rothesay about 5.10 p.m., for Wemyss Bay, Dunoon, Kirn, and Greenock, for Special Trains leaving Wemyss Bay at 5.45 p.m., for Glasgow, Edinburgh, and the South, and Greenock (Princes Pier) at 6.25 p.m., and Cathcart Street at 8.35 p.m. for Glasgow and Edinburgh.

Coaches in connection to and from Inveraray and Dalmally for Oban
Passengers through this varied Picturesque and Magnificent Scenery can have about Two Hours Ashore at Strachur and One Hour at Inveraray, the ancient capital of Argyllshire

	Fares—Return—1st Class and Saloon	2nd Class and Saloon	3rd Class and Steerage.
Glasgow to Strachur or Inveraray, via Greenock or Wemyss Bay,.........	7s 6d.	6s. 6d.	5s.
Greenock to Strachur or Inveraray,.....	Saloon, 5s. 6d.		Steerage, 3s. 6d.
Dunoon & W. Bay do. do.	Do. 4s. 6d.		Do. 3s. 0d.
Rothesay do. do.	Do. 4s. 0d.		Do. 2s. 6d.
Kyles of Bute do. do.	Do. 3s. 0d.		Do. 2s. 0d.

LOCH ECK ROUTE,
By Splendid Saloon Steamer "LORD OF THE ISLES," from Greenock at 8.15 a.m. to DUNOON (Train from Glasgow, St Enoch at 7.25 a.m. and Central at 7.30 a.m.); or Steamer "VIVID" to KILMUN—Train from Central at 8 a.m.; St Enoch at 8.10 a.m.; thence by COACHES to INVERCHAPEL, Steamer "FAIRY QUEEN" on LOCH ECK, COACHES to STRACHUR, STEAMER to INVERARAY, and COACHES to DALMALLY for OBAN; returning from Oban in July at 9.50 a.m., from Inveraray at 2.0 p.m., and from Strachur at 2.15 p.m., as above, for Greenock, Glasgow, Edinburgh, and the South.
Also by Steamer "IVANHOE" from Greenock at 9.55 a.m., for DUNOON (Train from Central at 9 a.m. and St Enoch at 8.55 a.m.); thence by COACHES from Dunoon and Kirn to INVERCHAPEL; Steamer "FAIRY QUEEN" on LOCH ECK, and COACHES to STRACHUR; returning from Strachur at 2.15 p.m., as above, for Greenock, Glasgow, Edinburgh, and the South.
For full particulars as to Circular Tours, Fares, etc., see Time Bills, to be had on board Steamers; at Railway Stations; from George Stirling, Jr., Dunoon; John Rodger, Inveraray; and from
M. T. CLARK, MANAGER,
17 Oswald Street, Glasgow.

An advertisement for sailings by *Lord of the Isles* to Inveraray from the late nineteenth century, also showing the Loch Eck Tour with a connection via Kilmun by *Vivid*, and via Dunoon by *Ivanhoe*, the latter only offering a trip as far as Strachur.

1896.
ROYAL ROUTE.
Price 1d.

ROUND THE CLOCK
A DAY'S SAILING on the Magnificent New Royal Mail Saloon Steamer
"Lord of the Isles"
BUILT 1891.

GLASGOW to INVERARAY and BACK (228 Miles), the Finest and Cheapest Day's Sail in Britain.

From GLASGOW (BRIDGE WHARF) Daily
AT 7-20 A.M.
Partick Wharf, 7-30 a.m.; Govan Wharf, 7-33 a.m.
TRAINS—CENTRAL, 8-45 a.m.; ST. ENOCH, 8-30 a.m.

RETURN FARES (Available for Season).
GLASGOW to INVERARAY, SALOON, 6/; FORE-SALOON, 3/6
GREENOCK " " 5/6 " 3/
DUNOON " " 4/6 " 3/
ROTHESAY " " 4/ " 2/
For Fares to intermediate Ports see Time Tables, Bills, &c.

Famed Loch Eck Tour—One-Day Coach Tour,
GLASGOW, 10/; GREENOCK, 10/; DUNOON, 9/.
Special Reduced Rates granted to English Tourists from Glasgow, Greenock, and Gourock, by Steamer to Inveraray and Loch Eck Tours, on presentation of Return Half of Railway Ticket.

Breakfasts, Luncheons, Dinners, and Teas served on board.
M. T. CLARK, 5 Oswald Street, Glasgow.

The cover of a publication entitled 'Round the clock on the Lord of the Isles', dated 1896.

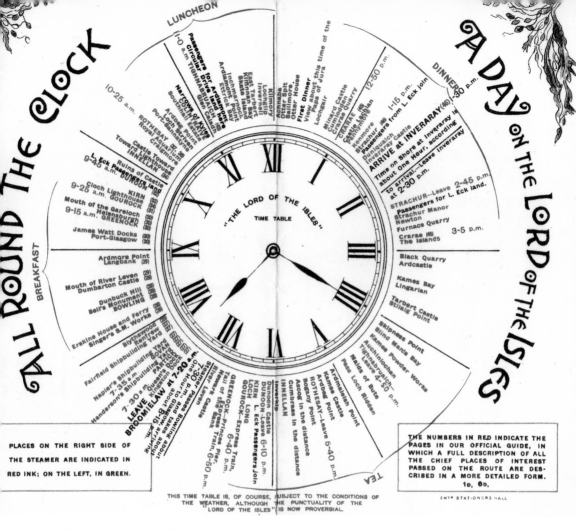

The interior of this publication, showing times at piers and passing landmarks.

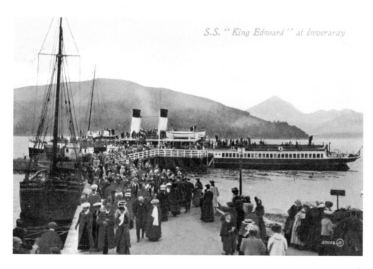

The pioneer turbine steamer *King Edward* served Inveraray from 1903 until 1927, and is seen here at the pier..

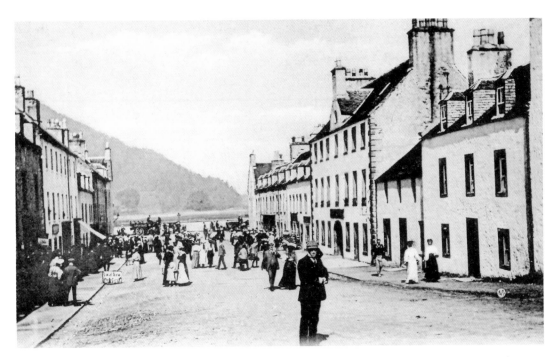

Passengers to Inveraray could visit the shops in the main street, seen here with a charabanc at the far end and pedestrians wandering in the middle of the street.

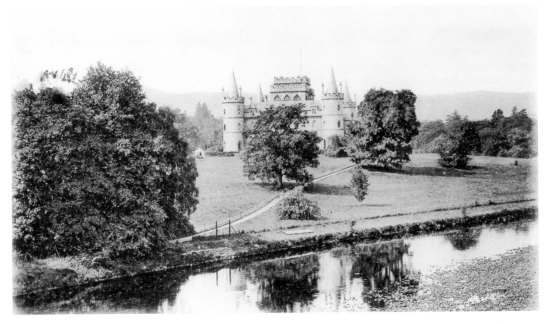

A visit to Inveraray Castle could also be made, seen here in a postcard posted in September 1903.

A crowded *Caledonia* berthed at Inveraray on a Clyde River Steamer Club charter sailing on 4 May 1968.

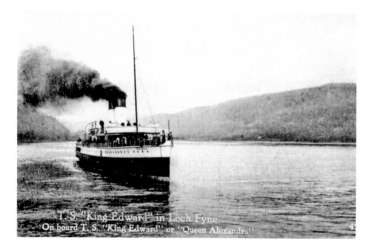

King Edward on the two-hour run up Loch Fyne in a copy of an official postcard available on board.

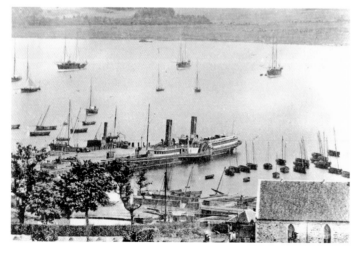

Ardrishaig was the terminus of the MacBrayne mail service from Glasgow. The 1864 *Iona* is seen here between 1888 and 1894 with the small MacBrayne cargo steamer *Udea* on the other side of the pier.

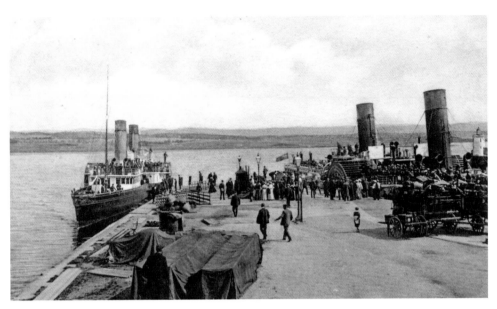

Iona arriving at Ardrishaig, with *Columba* berthed at the pier, in the days prior to the 1914 war, when *Iona* ran a second service from Wemyss Bay.

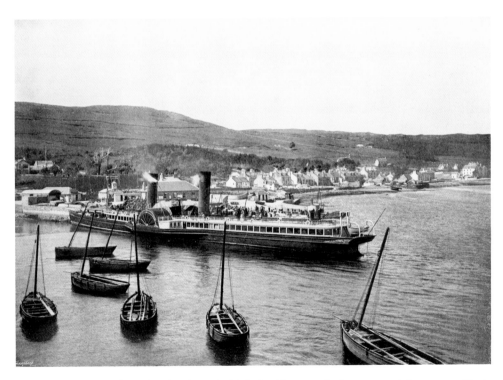

The famous *Columba* at her berth at Ardrishaig. She was the longest and finest ever Clyde paddle steamer and served the route in the summer months from 1878 until 1935. The pier remains in use for shipping of timber and sadly requests for calls by *Waverley* have been refused in recent years due to its commercial needs.

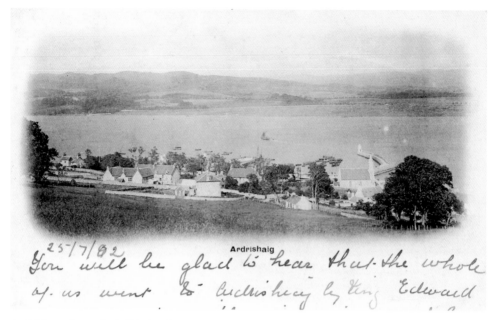

25/7/02

You will be glad to hear that the whole of us went to Ardrishaig by King Edward

Ardrishaig

Ardrishaig from the hill behind on a George Washington Wilson postcard posted on 27 July 1902. The message stated, 'You will be glad to hear that the whole of us went to Ardrishaig by *King Edward* today and enjoyed the sail immensely.' *King Edward* attempted to challenge *Columba* with an Ardrishaig service in 1902 before establishing herself on the Inveraray route from the following summer, although she continued to call at Ardrishaig until 1908.

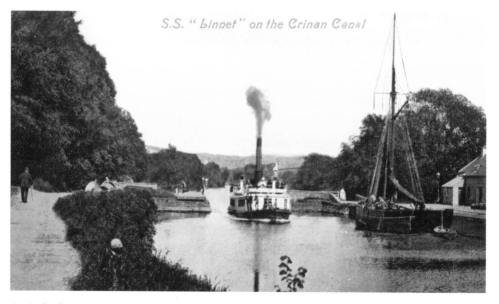

S.S. " Linnet " on the Crinan Canal

At Ardrishaig passengers could transfer to 'MacBrayne's floating tramcar', the small screw steamer *Linnet*, and sail through the Crinan Canal at Crinan. The photograph from which this Edwardian postcard was produced was taken prior to 1894, when she was fitted with a bridge and deckhouse.

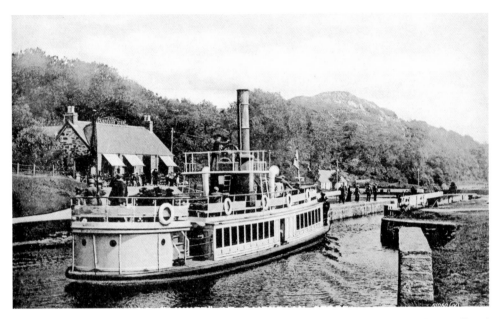

Linnet called, part-way along the canal, at Cairnbaan, where passengers could get off and patronise the shop and hotel, although the latter, being a temperance establishment, would not have satisfied the needs of all the passengers.

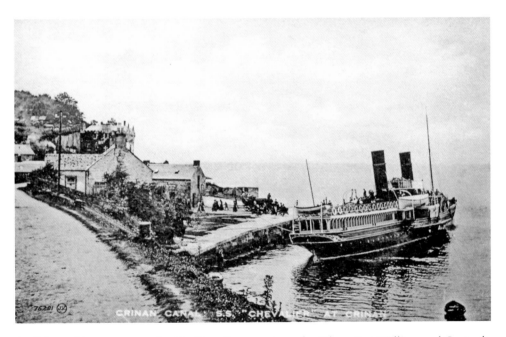

At Crinan, *Linnet* connected with *Chevalier*, seen here, for Oban, Fort William and Corpach, the entire journey from Glasgow being marketed as The Royal Route, following a trip by Queen Victoria in 1847, who had travelled it following a recommendation from the Russian Grand Duke Constantine, who had travelled it in the previous year. The pier was last used in 1995 by *Waverley*, and it is now unfit for use except by smaller craft.

The Kintyre Peninsula

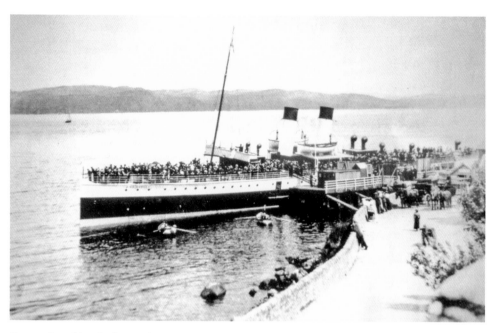

King Edward berthed at Tarbert Pier in 1902, the only year in which she called there.

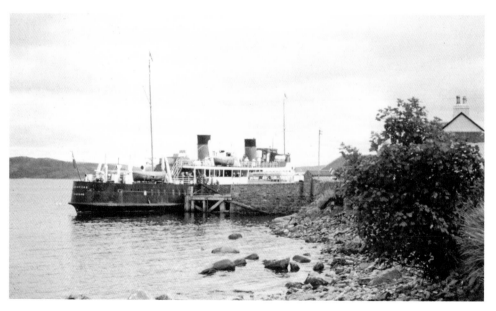

Lochfyne at Tarbert. She served the Tarbert and Ardrishaig mail run year-round from 1959 until 1969, and in winter prior to 1958.

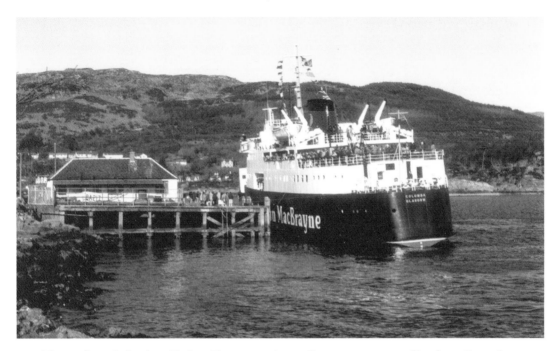

The car ferry *Columba* at Tarbert Pier, on a unique call on a pre-season sailing from Gourock to Oban in 1988.

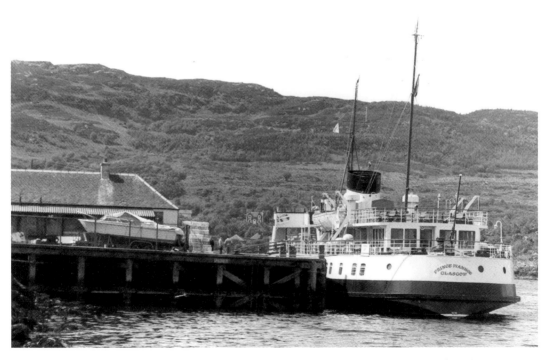

Prince Ivanhoe, ex *Shanklin*, at Tarbert on her all-too-brief sojourn on the Firth of Clyde, on 26 May 1981.

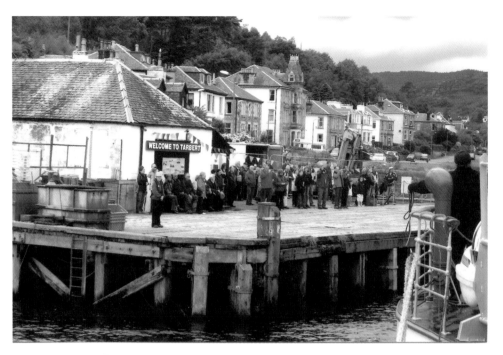

Passengers and well-wishers wait on Tarbert Pier for the arriving *Waverley*, on her first call there since her rebuild, in August 2000.

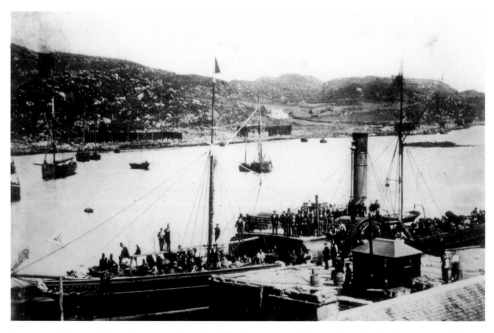

In one of the earliest photographs of a Clyde steamer, *Mary Jane*, built in 1846 and later MacBrayne's veteran *Glencoe*, is seen here in Tarbert harbour in 1858, prior to the pier being built. This photograph was discovered by Mr A. Fraser and was taken by a Miss Gray.

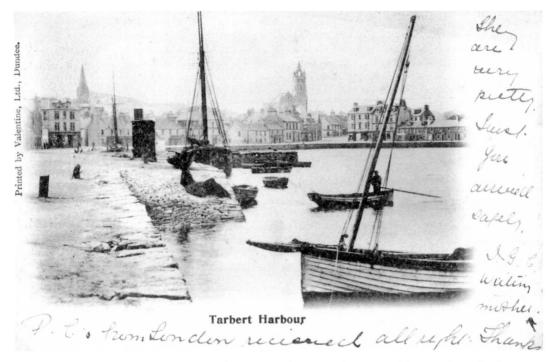

Printed by Valentine, Ltd., Dundee.

Tarbert Harbour

Tarbert Harbour in an early Edwardian postcard view. Tarbert is an old town, dating back to the thirteenth century. The isthmus between here and West Loch Tarbert was used in 1098 by Magnus Barefoot to drag a Viking longship across to include Kintyre as part of his possession of the Western Isles.

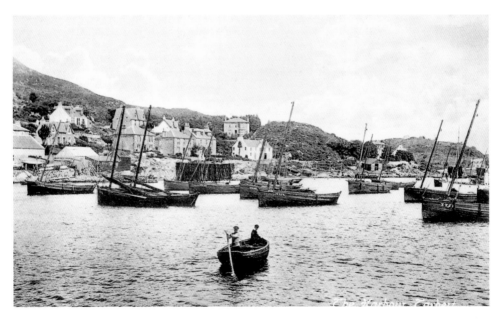

Tarbert had a large fishing fleet in the early years of the twentieth century, seen here in this postcard view. Nowadays the harbour is mainly used by pleasure craft.

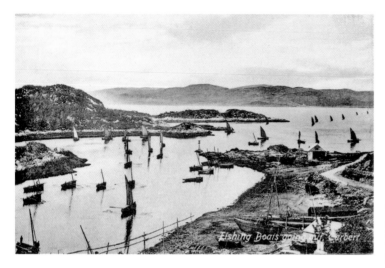

Tarbert's fleet of sail-powered fishing boats leaving harbour in a postcard view.

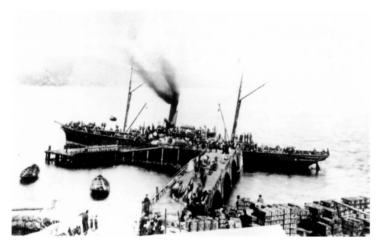

Carradale, a fishing port on the eastern shore of the Kintyre peninsula, was a call for the Campbeltown steamers. *Kintyre* of 1868 is seen there before her loss in 1907.

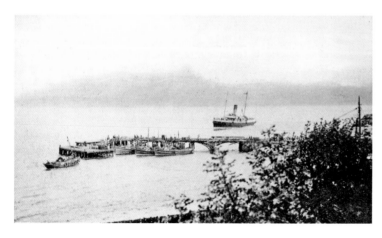

Dalriada arriving at Carradale in a 1930s postcard view. The harbour was used in 1993 for a very special call by *Waverley*.

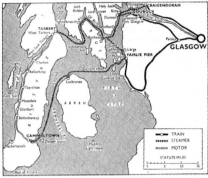

ON MONDAYS, THURSDAYS and SATURDAYS TOUR No. 3A
27th May to 25th September, also
ON TUESDAYS, WEDNESDAYS and FRIDAYS
27th June to 1st September

KYLES OF BUTE
TARBERT AND KINTYRE DAY TOUR

TRAIN TO GOUROCK OR CRAIGENDORAN; MESSRS MACBRAYNE'S
STEAMER VIA KYLES OF BUTE TO TARBERT (LOCH FYNE); MOTOR VIA
WEST COAST OF KINTYRE TO CAMPBELTOWN; STEAMER TO FAIRLIE,
GOUROCK OR CRAIGENDORAN AND TRAIN HOME

FARES FOR THE ROUND

From		1st Class	2nd Class	From	1st Class	2nd Class
Drumchapel	...	—	27/6	Greenock (Central) ...	25/9	25/-
‡Edinburgh	...	†44/-	38/-	Paisley (Gilmour Street)	30/-	28/-
*Glasgow	...	†30/9	28/6	Port Glasgow ...	26/9	25/9
From			Fare	From		Fare
Craigendoran	24/6	Largs	24/-
Dunoon	23/-	Rothesay	...	22/6
Gourock	24/-			

‡ Edinburgh (Princes Street or Waverley) Stations
* Glasgow (Central or Queen Street) Stations
† Second Class travel only between Glasgow (Queen Street) and Craigendoran
The tickets are valid on the date for which issued
FOR TRAIN, STEAMER AND MOTOR TIMES SEE OPPOSITE PAGE

36

The Kintyre Tour was a favourite circular tour in the fifties and sixties. Sailing to Tarbet by the MacBrayne mail steamer (*Saint Columba* until 1958, and *Lochfyne* from 1959 until 1969), then by bus to Campbeltown, and returning by steamer (normally *Duchess of Montrose* or *Duchess of Hamilton*) back to Fairlie or Gourock.

ON MONDAYS, THURSDAYS and SATURDAYS TOUR No. 3A
27th May to 25th September, also
ON TUESDAYS, WEDNESDAYS and FRIDAYS
27th June to 1st September

(For route map and fares see opposite page)

KYLES OF BUTE
TARBERT AND KINTYRE DAY TOUR

TRAIN, STEAMER AND MOTOR TIMES
(See important notice on inside cover page)

TRAIN

						am	am
Edinburgh (Princes Street)	leave	—	6 30	
Glasgow (Central)	arrive	—	8 5	
Glasgow (Queen Street)	leave	7*32	—	
Drumchapel	„	7*57	—	
Glasgow (Central)	„	—	8 23	
Paisley (Gilmour Street)	„	—	8 35	
Port Glasgow	„	—	8 55	
Greenock (Central)	„	—	9 2	
Gourock	arrive	—	9 13	
Craigendoran	„	8*34	—	

STEAMER

						am
Craigendoran	leave	8*40
Gourock	„		9 30
Dunoon	„		9 50
Innellan	„		10 5
Largs	„		9A20
Rothesay	„		10 35
Tighnabruaich	„		11 15
Tarbert	arrive		12 20 pm

MOTOR

						pm
Tarbert	leave	12 20
Campbeltown	arrive		2 10

STEAMER

						pm
Campbeltown	leave		3 15
Lochranza	arrive		4 35
Millport (Keppel Pier)	„		5§30
Fairlie Pier	„		5 45
Largs	„		6 0
Rothesay	„		6 40
Innellan	„		7B30
Dunoon	„		7 20
Gourock	„		7 40
Craigendoran	„		8B40

TRAIN

					pm	pm	pm
Fairlie Pier	leave	6 8	—	—
Gourock	„	—	7 53	—
Craigendoran	„	—	—	8 D 53
Drumchapel	arrive	—	—	9 D 27
Greenock (Central)	„	—	8 3	—
Port Glasgow	„	—	8 13	—
Paisley (Gilmour Street)	„	7 11	8 32	—
Glasgow (Central)	„	—	8 47	—
Glasgow (St. Enoch)	„	7 27	—	—
Glasgow (Queen Street)	„	—	—	9D47
Glasgow (Queen Street)	leave	8 0	10 C0	10 C0
Edinburgh (Waverley)	arrive	9 21	11 C6	11 C6

*Passengers change into Messrs MacBrayne's steamer at Rothesay (no connection after 9th September). ‡Saturdays excepted. A Tuesdays only and change into Messrs MacBrayne's steamer at Rothesay. B Change at Rothesay leaving at 7.0 pm (ceases after 9th September). C Leave Glasgow (Queen Street) 10.25 pm and arrive Edinburgh (Waverley) 11.49 pm on Saturdays until 10th June and from 16th September. D 12 minutes later on Saturdays from 17th June.

37

The 1961 timetable for the Kintyre Tour, showing connecting trains from as far away as Edinburgh.

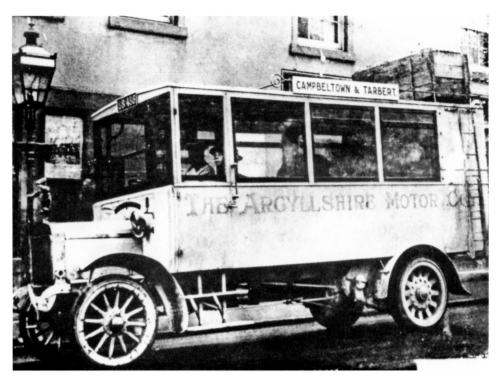

The bus from Tarbert to Campbeltown in 1961 was much more modern then this early vehicle.

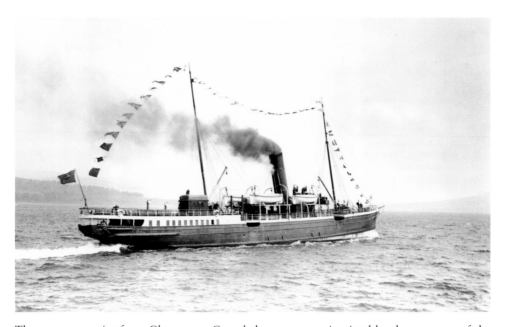

The steamer service from Glasgow to Campbeltown was maintained by the steamers of the Campbeltown & Glasgow Steam Packet Joint Stock Company up until 1940 with the venerable *Davaar* of 1885, notable for her clipper bow, and seen here departing from Gourock.

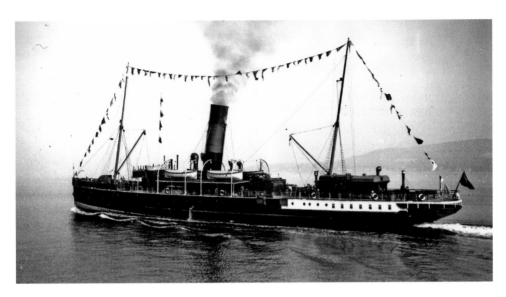

Davaar was joined in 1926 by *Dalriada*, with her extremely tall funnel, and, unusually for a steamer built at that time, still with reciprocating engines rather than turbines. She had four-cylinder triple expansion machinery and was reputed to be the fastest single screw steamer in the world when new. She is seen here on 6 May 1935, dressed overall for King George V's Silver Jubilee celebrations.

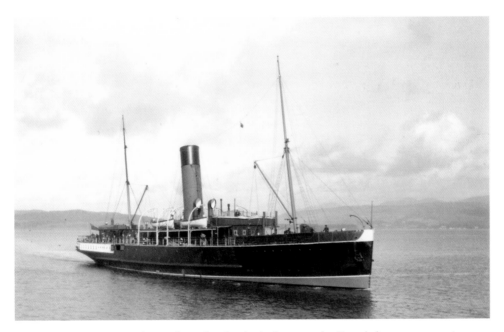

Dalriada in MacBrayne colours taken after they had taken over the Campbeltown company in 1937. She remained on the service until January 1940, when she in collision with a destroyer off Arran and was withdrawn from service. In April 1941, she was taken over by the Admiralty, meeting her end on 19 June 1942 when she struck a mine in the Thames Estuary whilst serving as a salvage vessel.

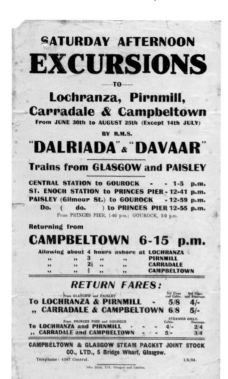

SATURDAY AFTERNOON

EXCURSIONS

—TO—

Lochranza, Pirnmill,
Carradale & Campbeltown

From JUNE 30th to AUGUST 25th (Except 14th JULY)

BY R.M.S.

"DALRIADA" & "DAVAAR"

Trains from GLASGOW and PAISLEY

CENTRAL STATION to GOUROCK - - 1-5 p.m.
ST. ENOCH STATION to PRINCES PIER - 12-41 p.m.
PAISLEY (Gilmour St.) to GOUROCK - 12-59 p.m.
 Do. (do.) to PRINCES PIER 12-55 p.m.
 From PRINCES PIER, 1-40 p.m.; GOUROCK, 2-0 p.m.

Returning from

CAMPBELTOWN 6-15 p.m.

Allowing about 4 hours ashore at LOCHRANZA
 " " 3 " " PIRNMILL
 " " 2½ " " CARRADALE
 " " ¾ " " CAMPBELTOWN

RETURN FARES:

	1st Class and Cabin.	3rd Class and Steerage.
From GLASGOW and PAISLEY		
To LOCHRANZA & PIRNMILL -	5/8	4/-
" CARRADALE & CAMPBELTOWN	6/8	5/-
From PRINCES PIER and GOUROCK	STEAMER ONLY. Cabin.	Steerage.
To LOCHRANZA and PIRNMILL - - -	4/-	2/4
" CARRADALE and CAMPBELTOWN - -	5/-	3/4

CAMPBELTOWN & GLASGOW STEAM PACKET JOINT STOCK
CO., LTD., 5 Bridge Wharf, Glasgow.

Telephone: 4307 Central. 1/6/34.

John Horn, Ltd., Glasgow and London.

Left: A 1934 handbill for afternoon excursions from Greenock (Princes Pier) and Gourock, with connecting trains from Glasgow and Paisley, to Campbeltown.

Below: Davaar loading or unloading cargo at Campbeltown in her 1937 to 1939 MacBrayne livery, with the turbine steamer *Glen Sannox* across the end of the pier. The latter had arrived from Ardrossan and the east Arran piers.

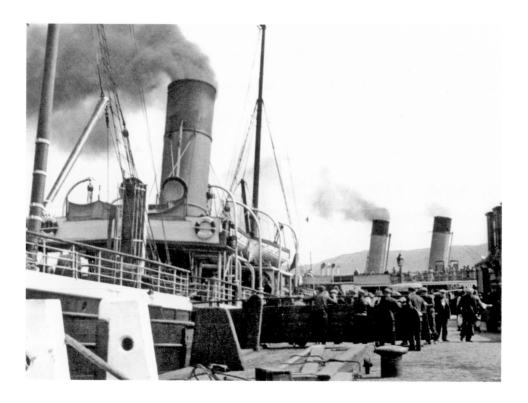

Campbeltown was the original destination for the pioneer turbine steamer *King Edward* in 1901, and for the new *Queen Alexandra*, seen here, from 1902. Also just visible behind the shed are the mast and funnel of an unknown steamer on an excursion from Belfast or Larne.

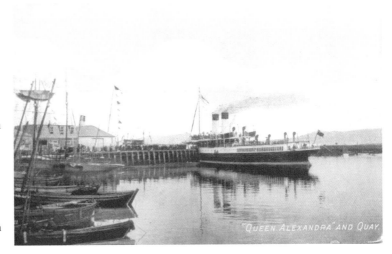

"QUEEN ALEXANDRA" AND QUAY.

An unidentified coastal steamer, possibly a visitor from Northern Island and the 1902 *Queen Alexandra* berthed in the more usual position at Campbeltown, in an Edwardian postcard view.

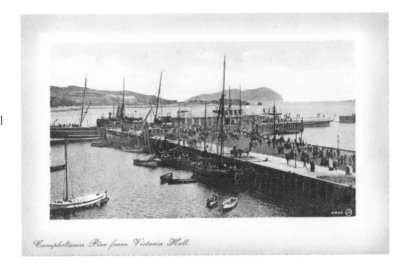

Campbeltown Pier from Victoria Hall

The 1912 *Queen Alexandra*, photographed after her promenade deck had been enclosed in 1932, in a postcard view still on sale in Campbeltown in 1969.

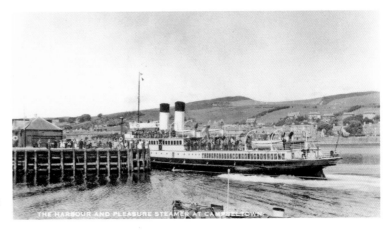

THE HARBOUR AND PLEASURE STEAMER AT CAMPBELTOWN.

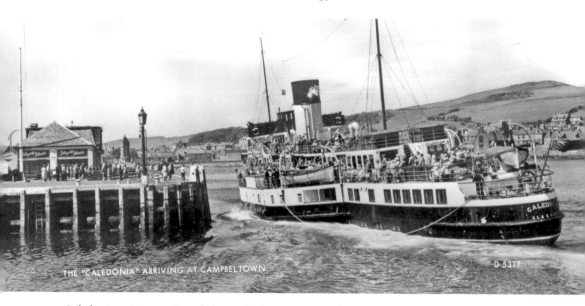

THE "CALEDONIA" ARRIVING AT CAMPBELTOWN D 5317

Caledonia arriving at Campbeltown in the 1950s or early 1960s, on an excursion from Ayr.

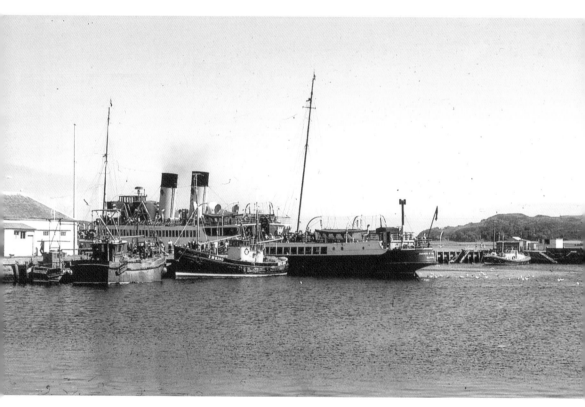

Duchess of Hamilton berthed at Campbeltown in the 1965–69 blue hull period. She was the main Campbeltown steamer in the post-war years until her withdrawal in 1970, with a daily service until 1964, and thrice weekly thereafter.

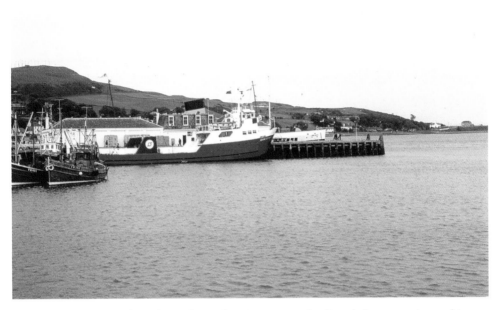

Queen Mary II replaced *Duchess of Hamilton* in 1971 on the Campbeltown service, and is seen here hiding behind the sheds, with Western Ferries' *Sound of Islay*, which ran a car ferry service from there to Red Bay in Northern Ireland from 1970 until 1973.

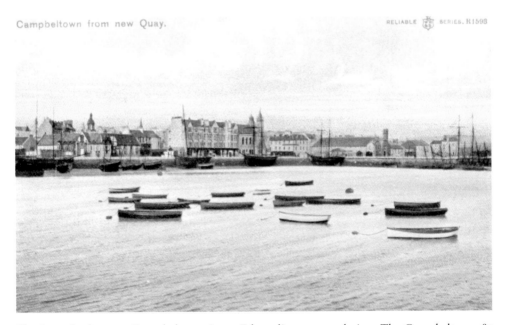

The inner harbour at Campbeltown in an Edwardian postcard view. The Campbeltown & Macrihanish Light Railway departed from in front of the tall buildings in the centre of the picture.

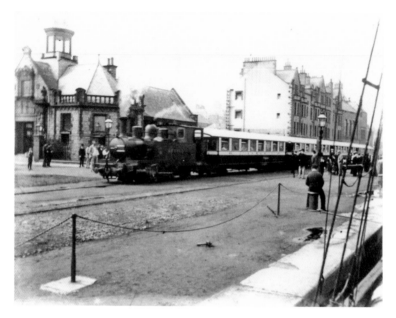

The 2-foot, 3-inch gauge Campbeltown & Macrihanish Light Railway operated from 1906 until 1932, and provided a short excursion for passengers arriving by steamer. A train is seen here departing from Campbeltown.

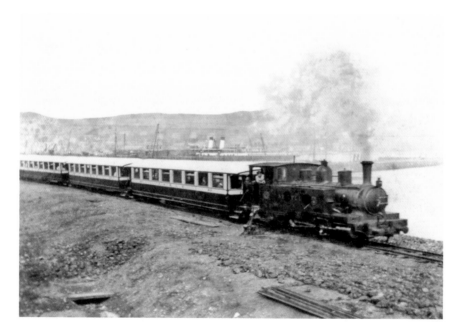

A train departs Campbeltown for Macrihanish, with the 1912 *Queen Alexandra* berthed at the pier in the background.

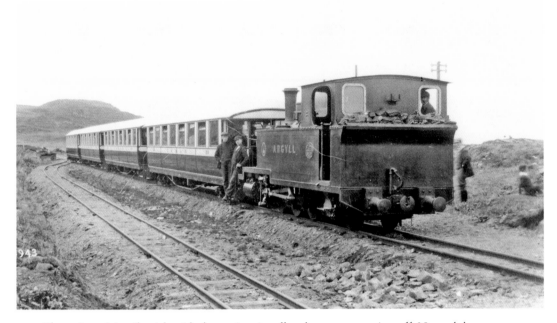

The train at Macrihanish with the engine *Argyll* and two men getting off. No such luxury as a platform here!

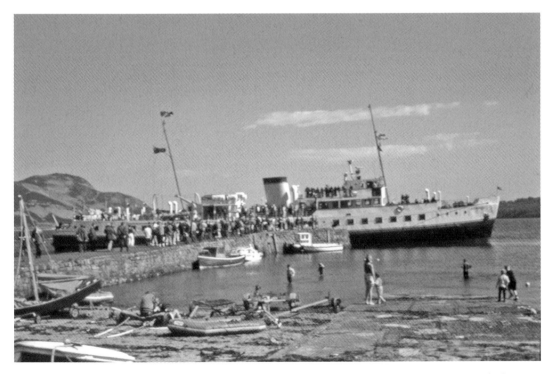

Macrihanish provided sandy beaches (on the shores of the Atlantic) and distant views of Islay and Jura.

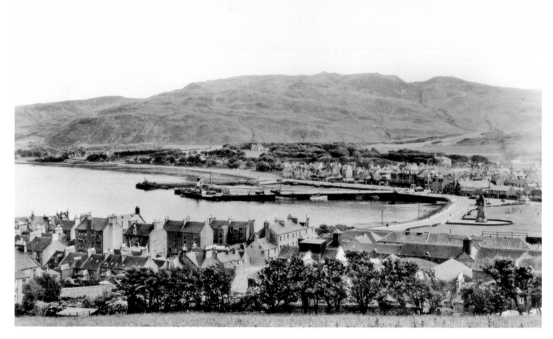

Campbeltown from the north-west with *Dalriada* berthed at the pier. Campbeltown is an old-established town and at one time had thirty-four whisky distilleries, possibly the origin of the song, 'Campbeltown Loch, I wish you were whisky.' Only three distilleries remain in the town today.

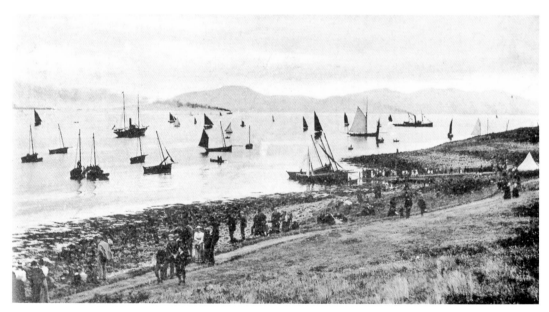

An Edwardian yachting regatta off Davaar Island at the entrance to Campbeltown Loch, with a couple of unidentified steamers in the distance.